WILD WOMEN *of* MARYLAND

Grit & Gumption in the
Free State

LAUREN R. SILBERMAN
FOREWORD BY DIANA M. BAILEY

THE
History
PRESS

Published by The History Press
Charleston, SC 29403
www.historypress.net

Copyright © 2015 by Lauren R. Silberman
All rights reserved

First published 2015

Manufactured in the United States

ISBN 978.1.62619.811.1

Library of Congress Control Number: 2015943176

CONTENTS

CONTENTS

HERSTORY IN MARYLAND

Women in Maryland have been making history for centuries, but until the last few decades, those contributions have often been overlooked. Thousands of unsung heroines never made it to the textbooks or into exhibits at historic sites. Students, especially young women, rarely saw or read about role models who may have related to them personally or as someone doing interesting work in their careers and lives.

When I was a young student, I did hear about a few famous women. My mother loved American history. I remember her comments about Abigail Adams and Eleanor Roosevelt and the many roles they performed for their husbands. Eventually each gained her own "voice" as she worked to improve the lives of American women and their families.

As a young girl, I heard about Amelia Earhart, a woman who, I thought, did "cool things"—as an aviator who had adventures but died tragically. I did not learn about Bessie Colman, Jackie Cochran and other female pilots until I was much older. It always appeared that there was just one woman, not many women, doing remarkable things.

My school and the local library resources had very limited information about women, especially those who may have been of any sort of minority—Jewish, African American, Native American—immigrants or with a disability. As women, their roles and contributions were essentially invisible. Many made huge sacrifices for their families, communities or states, but they were often unsung heroines, even within their families. It was only later that I learned that there were female pioneers and leaders in careers

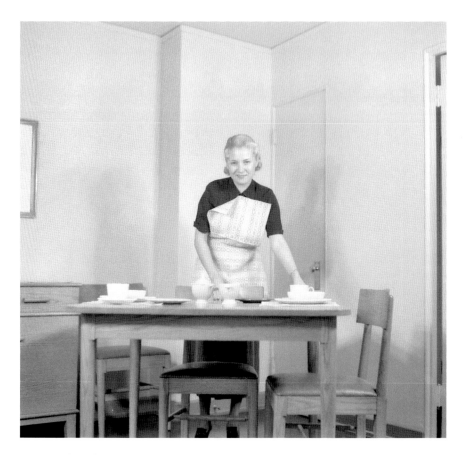

A housewife in Greenbelt, Maryland. *Library of Congress.*

such as medicine, astronomy, education and law. Many times their work or inventions were credited to male counterparts or family members.

My parents did not have the opportunity to complete college, but it was one of their priorities for their children. Although my brothers, sister and I were expected to go to college, the messages about careers were very different for my sister and me than for my brothers. It seemed to me that my choices were to become a nurse, educator, secretary or some type of support person. My career guidance was only to get into college and graduate. As a woman, I did not feel I had the same choices as my brothers.

Fortunately, today, the options for women are significantly greater, but there continue to be significant barriers and challenges for young women. Given the broad economic and cultural diversity in Maryland, we still must be vigilant in sharing the stories of women who came before us and paved

the way for future generations. Our challenge is to ensure that each young woman and man has the opportunity and support to achieve his or her potential and follow his or her dreams.

I am unfortunately not alone in my limited past understanding of women's history and the roles that so many women, famous and unsung, have played in Maryland, our nation and across the globe. In response to this need, the Maryland Commission for Women, in partnership with the Women Legislators and the Maryland State Department of Education, established the Maryland Women's Hall of Fame in 1985, recognizing historic and contemporary women for their extraordinary work in social activism, science, social justice, arts and education. Since then, five or six women are selected annually in a difficult, competitive process.

As a member of the Maryland Commission for Women, I served as co-chair of that selection process and event for several years. As I learned more about these extraordinary pioneers, others in Maryland were finding additional ways for women's stories to be heard and made available to the public. Many of these women became my role models and mentors as I grew professionally and into leadership roles.

During the resurgence of the women's movement in the '70s, the exploration of women's contributions became a strategy to elevate the perception of the value of our gender. Female participation in education, career choices and workplace roles began expanding. Though women were underrepresented in education programs and employment, nonwhite women had additional challenges to deal with and overcome. Sadly, even today, women still have achieved pay equity of only 78 percent that of their male counterparts. Minority women generally have even lesser salary outcomes.

In Maryland, we were fortunate to have some early women who made significant contributions to our state. Many adults and youth know something about Harriett Tubman and Senator Barbara Mikulski. However, few know about other women from the state.

Things are starting to change. For example, the contributions of those serving in World War II have been rediscovered. Finally, the roles of women in the military or those serving at home, or as Rosie the Riveters, have become more visible in families and educational resources. In many families, there was little or no conversation about those varied and important roles. When their service was over, these brave women were usually displaced by men and returned to previous lesser roles whether they wanted to or not.

In early 2000, Maryland Women's Heritage Center's founder and now Executive Director Emerita Jill Moss Greenberg and Linda Shevitz, former

gender equity specialist of the State Department of Education, formed the vision for the Maryland Women's Heritage Center (MWHC). Greenberg, Shevitz and others were the initial board of directors and longtime program chairpeople. An active president, former First Lady of Maryland Frances Hughes Glendening, chaired the board of directors. Past and current First Ladies have served on the board and as honorary chairs of MWHC events or programs.

Today, the MWHC—a 501(c)(3) nonprofit, nonpartisan organization—works to preserve the past, understand the present and shape the future by recognizing, respecting and transmitting the experiences and contributions of Maryland women of diverse backgrounds and from all regions of the state. The MWHC is an outgrowth of the Maryland Women's History Project that began as a collaborative venture between the Maryland Commission for Women and the Maryland State Department of Education. For many years, it produced the Maryland Women's History in bulletin board kits and instructional materials that were disseminated across the state to schools and local libraries. There was an emphasis on the materials, as on other school activities, but activities seemed to be heavily focused only during Women's History Month in March with little emphasis during the rest of the year.

The MWHC board and supporters have been working to expand the awareness and knowledge of the value of past contributions of women and why it is relevant to future generations of young women and men. In 2007, the MWHC opened its doors in Baltimore, and visitors began attending events and programs and visiting the Hall of Fame exhibit, as well as the exhibit Images and Expressions: Maryland Women in the Arts on women in social justice and careers in STEM (science, technology, engineering and math), which opened in June 2015. The first comprehensive state center of its kind in the nation, the Maryland Women's Heritage Center honors Maryland's historic and contemporary renowned women and girls who have been inducted into the Maryland Women's Hall of Fame, as well as the unsung heroines who have shaped their families and communities. It serves as a national model that can be replicated and adapted by other states and countries to honor the women and girls in their borders. We celebrate Women's History Month every month and not just in March.

Philosophically, the MWHC also wants to recognize women in Maryland who make significant contributions to the workplace, community and their families. To that effort, we have an exhibit highlighting many unsung heroines who have made some unique contributions. It is critical for students to also see themselves with the responsibility and personal

Working on ordnance, Aberdeen, Maryland. *Library of Congress.*

power to become active members of society and meet their workplace potential and economic self-sufficiency. Although we do still have the continuing wage gap, women must learn to be self-advocates, to ensure their productive participation in the workforce and appropriate pay and recognition for their contributions.

Maryland's little-known heroines were first defined in the book *Notable Maryland Women* by Winifred Helmes. This description was adapted somewhat for today's realities and was published in *Women of Achievement in Maryland History*, written by Carolyn Stegman, a former member of the MWHC Board of Directors, and initiated by Frances Hughes Glendening, MWHC president. At a high level, Maryland's unsung heroine was described in the following way:

> *Beyond the "notable" Maryland women are the unsung heroines—your mother, grandmother, sister, aunt, daughter, neighbor, and friend. Their partnership in building our communities and strength in building our families has often gone unrecognized and unpraised. Yet without each "heroine" there would have been no state of Maryland—no country—no America.*

FOREWORD

There is so much more to learn about Maryland women and their stories. This new book by Ms. Silberman will add to the literature and resources about famous and unsung women in Maryland. It will also give young women the support they need to find their own voices and encourage them to become the people they are capable of becoming. As we say at MWHC, by adding "HERstory to HIStory, we can tell OURstory."

After you have read this book, please come visit the Maryland Women's Heritage Center to learn more about our "HERstory."

DIANA M. BAILEY
Executive Director
Maryland Women's Heritage Center
mwhcdiana@gmail.com
www.MDwomensheritagecenter.org

INTRODUCTION

I'm with Barbara," asserts a recent campaign initiated by Preservation
Maryland, a nonprofit dedicated to protecting the state's historic and
natural treasures.

Who was Barbara? None other than the elderly Barbara Fritchie, who lived
in Frederick during the Civil War. According to folklore, Barbara refused to
stop waving her Union flag, even as Frederick was besieged by Confederates.
Although well into her nineties at the time, she wouldn't surrender her
patriotic spirit—no matter that it was General "Stonewall" Jackson himself
leading Southern troops through the city as part of the Maryland Campaign.
Inspired by her actions, the famous poet John Greenleaf Whittier wrote
"Barbara Frietchie," writing in part:

> "Shoot, if you must, this old gray head,
> But spare your country's flag," she said.
> A shade of sadness, a blush of shame,
> Over the face of the leader came;
> The nobler nature within him stirred
> To life at that woman's deed and word;
> "Who touches a hair of yon gray head
> Dies like a dog! March on!" he said.

Did Barbara purposely leave her flag on display that fateful day? The truth
is murky. According to some accounts, she was sick in bed that day and the flag

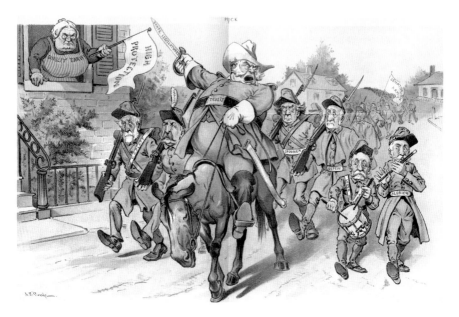

Political cartoon from *Puck* magazine showing senators as Confederate soldiers marching past Barbara Fritchie's house in Frederick, Maryland. *Library of Congress.*

left flying was simply one that had been forgotten. Or perhaps she truly was an undeterred Unionist willing to face death for her ideals. Either way, her spirit continues to evoke strong feelings—be it poetry or preservation—today. Her house has even been reconstructed and now serves as a museum.

Barbara Fritchie is indicative of Maryland's "wild women"—those independent spirits who defied the social conventions of their time periods and charted their own stories. Many of the Old Line State's earliest "dangerous dames" are now revered as pioneers, women who pushed back at societal expectations and blazed new trails of progress for their descendants.

But not all the wild women have become illustrious. Others dallied on the wrong side of the law, and some of them we still see as criminal today. There were thieves and murderers, just as there were originators and innovators.

Indeed, pinpointing the exact definition of "wild" has been a journey unto itself. I decided that a "wild woman" wasn't simply the first person (let alone the first woman) to do something special, but she had a remarkable story that highlighted her resolve and her choices. This became my main criterion for inclusion. I also followed the guidelines espoused by Canden Schwantes's *Wild Women of Washington, D.C.* (The History Press, 2014). Her book was the inspiration for this project. She writes, "What makes these women 'wild' is

that they went against the social norms and common perceptions of what was appropriate for a lady of the times."

Such a woman couldn't be easily cowed, even when the entirety of society believed her a renegade. Throughout much of American history, especially during the Victorian era of the nineteenth century, the general feeling was that a woman belonged in a submissive and domestic role. So, a wild woman needed to be able to rise above convention for what she believed in, whether good or bad.

A stylistic note about this book: I've left quotes intact as originally printed, so there may be misspellings or other errors. Occasionally I have included a small note in brackets or have used sections of quotes, as generally demarcated by ellipses. I've tried to acknowledge where to find the quote in the text of each section, and there is a bibliography in the back, as well as an index.

Frankly, it would be impossible to include profiles of every noteworthy Maryland woman; this book would probably have several volumes! Some previous books have attempted this Herculean effort, including *Women of Achievement in Maryland History*, edited by Carolyn B. Stegman with over four hundred entries, and *Notable Maryland Women*, edited by Winifred G. Helmes and featuring several dozen ladies. On a smaller but equally important scale is *Courageous Women of Maryland*, by Katherine Kenny and Eleanor Randrup, which profiles eighteen women. I am in debt to the work done by all of these editors and contributors. I didn't want to simply replicate their efforts. *Wild Women of Maryland* has a different tone from these works and includes several people not covered in either, although there is some overlap.

Similarly, Claudia Floyd's *Maryland Women in the Civil War* provides far more information about the women involved during that turbulent time. We have a few shared ladies, but I would recommend her work for a more intensive study of the period.

Also, in Schwantes's *Wild Women of Washington, D.C.*, some women with Maryland connections, such as Clara Barton and Rose O'Neal Greenhow, are included because of their work within the nation's capital. I've tried to complement and not simply repeat her work.

Another fantastic resource on Maryland women is the Maryland Women's Heritage Center; I am in debt to its willingness to help steer me on this project. Located in downtown Baltimore, it does an admirable job of celebrating not only Maryland's most recognizable female names but also the innumerable "unsung heroines." Learn more at http://mdwomensheritagecenter.org. My great thanks to its managing director, Diana Bailey, for penning the foreword to this book.

Greenbelt band members. *Library of Congress.*

I also recommend the annual Maryland History and Culture Bibliography produced by the University of Maryland Libraries. You can search by several different categories, including women. The University of Maryland also provides a digital guide to women in Maryland. Both links are available at www.lsilberman.com, as are additional useful books, websites and resources. The majority can also be found in the bibliography. I was fortunate to receive such considerate assistance from the librarians with the University of Maryland–College Park, especially in their fantastic Maryland Room.

And of course, I have not been able to complete any of my books without the outstanding treasure-troves of the Pratt Free Public Library's Maryland Room and African American Department along with the Maryland Historical Society, both in downtown Baltimore. Additionally, each has incredibly useful resources online. The Pratt Library (www.prattlibrary. org) offers access to searchable historic newspapers online with just one's library card number, and the Maryland Historical Society provides over

one hundred years of its *Maryland Historical Magazine* through its website (www.mdhs.org).

The Library of Congress (www.loc.gov) and Ancestry.com (www.ancestry.com) should be pointed out, as they are intense online resources with extensive content. I'm also grateful to the members of the Maryland Museum Association (previously the Maryland Association of History Museums) listserv (http://www.mahm.org/), as well as the followers on the *Wicked Baltimore* Facebook page (www.facebook.com/wickedbaltimore) for their suggestions and encouragement.

I've tried to include some new faces, faces that I introduced in my last book, *Wicked Baltimore: Charm City Sin and Scandal* (The History Press, 2011). As a result, you'll find references to such remarkable ladies as Betsy Patterson, Blaze Starr, Ellen Wharton and Billie Holiday; there were so many other amazing stories to share that I didn't want to just recount the same names. Check out *Wicked Baltimore* for more on these extraordinary women.

All of this is to say that Maryland is overrun with the richness of effort by its female residents.

ACKNOWLEDGEMENTS

Thank you to everyone who assisted with my research requests, including but not limited to Diana Bailey and Bea Dane of the Maryland Women's Heritage Center; Doug McElrath and Tim Hackman of the University of Maryland Libraries; staff of the Maryland Room of the Enoch Pratt Free Library; Emily Oland Squires and Maria Day of the Maryland State Archives; William Cooke, author of *Witch Trials, Legends and Lore of Maryland: Dark, Strange, and True Tales*; Dr. Joseph Fitzgerald, author of the upcoming book *The Struggle Is Eternal: Gloria Richardson and Black Liberation*; Rod Cofield of Historic London Town and Gardens; Eric Harbeson; Christine Henry; Diane Knuckles of the Ocean City Life Saving Station Museum; Kate Livie of the Chesapeake Bay Maritime Museum; Aaron Marcavitch of the Anacostia Trails Heritage Area/Maryland Milestones; Julie Messick; Alfonso Narvaez; Faye Rivkin; Karen Ronne Tupek; Anna Socrates; Heather Taylor, documentary filmmaker; Allison Titman of the American Alliance of Museums; Allison Weiss of Sandy Spring Museum; Todd Welsh; Rick Wilson; and everyone who suggested names, contacts and ideas on Facebook and through the Maryland Museums Association listserv.

Thank you as well to everyone with The History Press, especially my commissioning editor Hannah Cassilly, who continues to be a champion for promoting widespread access to regional history.

And of course, thanks to my family, especially my husband, Matt Moffett. It's always helpful to have a librarian for a husband. Matt, you are my secret research weapon.

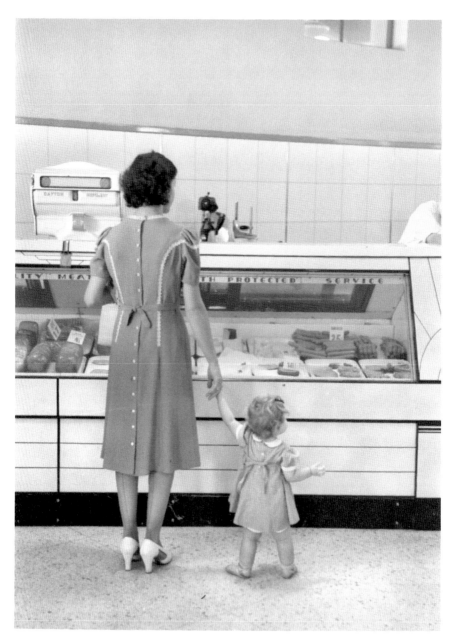

Greenbelt mother and child in grocery store. *Library of Congress.*

Chapter 1
PIONEERING SPIRITS

Maryland's Colonial Ladies

When Maryland was permanently settled by the British in 1634, the small colony consisted of only a few hundred colonists. While the majority of the settlers were men, several women made the trip as well, coming as indentured servants, wives and family members and even a few as independent landowners. All faced unknowable but exciting possibilities, far removed from their lives in England. Some came for the adventure or the potential of wealth, while others sought to escape hard times back home, even if that meant abandoning everyone and everything they knew. Just by daring to journey to a new continent, these women were trailblazers.

MARGARET BRENT: THE SOMEWHAT SUFFRAGIST
ca. 1601–ca. 1671, St. Mary's City

Take, for example, Margaret Brent—one of Maryland's earliest residents. With her sister Mary and two brothers Fulke and Giles, the thirty-eight-year-old Margaret arrived in 1639, only five years after the colony had been settled. Unlike most other women, her family was already wealthy. She likely ventured to the fledgling colony for its promise of religious freedom for Catholics, something that didn't exist in the Anglican-dominant England. As it turned out, they left none too soon because in

1642, their home county became embroiled in civil war, erupting along religious and political lines.

Fulke didn't remain in Maryland long, returning to England. Giles moved to Kent Island. With Mary, Margaret headed farther south, establishing "Sister's Freehold," an estate near present-day St. Mary's City. The family had brought with them several indentured servants and managed two thousand acres of land.

The unmarried Brent sisters flourished, becoming well-to-do planters and entrepreneurs. Margaret lent monies to other newly arriving settlers, appearing frequently in early records for debt collection and business affairs issues. Even with their success, the early years were not easy ones. A large number of settlers—estimated at 20 to 30 percent—died within their first year of arrival. Even if they survived that initial "seasoning" period, most colonial men died at a younger age than their British counterparts. The majority didn't make it to fifty years.

Furthermore, England's civil war had spread to Maryland in 1642. Richard Ingle, a Protestant ship's captain, raided the settlement, claiming his attack in the name of the English Parliament. The violence was partially the Brent family's fault. Margaret's brother Giles had been serving as acting governor when he managed to antagonize Richard.

Giles was relieved of the position when the actual governor, Leonard Calvert, returned from England. Finding the colony in chaos, Leonard holed up with his supporters in a hastily constructed fort on Margaret and Mary's land. The sisters were likely among those seeking refuge. In return, Richard took over the governor's house as his stronghold. His followers burned the town's Catholic chapel, looted houses and took ships as prizes.

During the ensuing mêlée, Giles was captured and carted back to England. Leonard, on the other hand, escaped south to Virginia. Margaret and Mary remained in Maryland. The settlement, which had grown to maybe six hundred people, now plummeted to fewer than one hundred. There was talk of shutting down the colony entirely. Leonard didn't give up. He spent a year amassing soldiers to fight back. In 1646, he successfully defeated Richard Ingle and brought a temporary peace back to Maryland. Giles Brent safely returned to his sisters.

Just before he passed away in 1647, Leonard named Margaret executor of his estate. He instructed her to "take all and pay all," meaning to compensate the soldiers who had fought against Richard Ingle. Selecting Margaret was a fairly surprising move, since women of the time period generally had limited political powers. While husbands regularly designated their wives as their

estates' executrix, Margaret was unmarried. Remaining single may have been her choice, since she could own and manage property but would have lost that power if she took a husband.

Margaret tried to pay back the soldiers as he had instructed. Unfortunately, there wasn't enough money. The soldiers became incensed. At the same time, the colony was also suffering through a food shortage, and hungry soldiers were dangerous soldiers. Margaret had to act fast. These men were hired hands whose loyalty extended only as far as their wallets. While they had fought against Richard, they could just as easily change sides.

Margaret sought help from the provincial court. Leonard Calvert had been serving as the attorney on behalf of his older brother Cecil, the Lord Baltimore. With neither Calvert alive or present, Margaret asked if she could fill that void. The court concurred.

Endowed with some power, Margaret then went to the assembly, a precursor to a state's modern-day legislature. On January 21, 1648, she asked for two votes: one for herself, a landowner, and one as the Lord Baltimore's counsel. Then, she could have helped promote a tax to pay for the mercenaries. She would have also been on the same political footing as the other property-bearing, free white men.

The assembly denied her request.

Margaret, however, was not a person easily quashed. She went ahead and began selling off Leonard's property, including his cattle. The money went to the soldiers, appeasing them. Maryland was saved from any potential riots or uprisings. Unfortunately, Cecil Calvert learned about Margaret's actions. Although he lived back in England and had never even been to Maryland, he would have expected her to ask for permission to sell what he saw as his property. Instead of thanking her for stabilizing an unsafe situation, Cecil condemned Margaret.

While the men of the assembly were not ready to see Margaret as their equal, they did nonetheless rush to her defense. They wrote to Cecil:

> *We do Verily Believe and in Conscience report that it was better for the Collonys safety at that time in her hands than in any mans else in the whole Province…for the Soldiers would never have treated any other with that Civility and respect and though they were even ready at several times to run into mutiny yet she still pacified them…She rather deserved favour and thanks from your Honour for her so much Concurring to the publick safety then to be justly liable to…bitter invectives.*

Cecil was not placated. The assembly decided to levy a tax on tobacco exports to raise the funds for the soldiers' wages, mollifying the situation.

By 1649, Margaret and Giles had left Maryland for Virginia, while their sister Mary apparently stayed behind. Mary continued to maintain their properties. Margaret, meanwhile, acquired a new plot of land, naming it Peace. She spent her remaining years there, passing away in 1671 at the age of seventy.

Many people today see Margaret Brent as a forerunner of the suffragist movement. However, we do not know what her thoughts were on other women acquiring political power. While it is true that the steps she took toward voting were revolutionary, they were for her and her colony's benefit alone, not necessarily for her sex's progression. The fact that both Margaret and her sister Mary became well-to-do and respected was remarkable, especially in a place where men greatly outnumbered women. In general, however, most colonial women faced difficult times, as evidenced by one of Margaret's own indentured servants, Mary Lawne.

MARY LAWNE COURTNEY CLOCKER: THE THIEVING MIDWIFE
ca. 1620s, St. Mary's City

Mary Lawne came with Margaret Brent from England as a young woman in the late 1630s. It's unclear how many years she would have been indentured to Margaret, but it was likely at least four. During that time, Mary would have been essentially Margaret's slave, doing any services her mistress requested. In return, Margaret had not only sponsored Mary coming to America, but she would have also provided for Mary's basic needs.

However, within a year of arriving in the New World, Mary married James Courtney, who paid out the remainder of her contract with Margaret. They had a son together before James died in 1643. With more men than women in the colony, it didn't take long for Mary to remarry, this time to Daniel Clocker. Daniel had also been an indentured servant. Now, he was a tenant farmer and became a justice of the peace. Mary worked as a midwife.

As a midwife, Mary helped with several childbirths, even testifying on behalf of families who had stillborn children. In 1651, she gave crucial testimony during a case against Captain William Mitchell. William had impregnated Susan Warren. Susan claimed that early in her pregnancy William had given her

Midwife in practice. *Author's collection.*

Midwife in practice. *Author's collection.*

a strange "physick" to abort the fetus. However, while the baby had not survived birth, it had reached full term, indicating that the attempt was unsuccessful. While Mary's statement saved the couple from charges of infanticide, they were still found guilty on lesser charges: Susan was whipped for fornication, while William was fined and stripped of his office for adultery and attempted abortion.

However, in 1659, Mary Clocker found herself on trial for her life.

Mary served as the midwife during Mrs. Simon Overzee's labor. Her husband, a Dutch merchant, was away. While the child survived, unfortunately, the mother did not.

Daniel Clocker built a coffin for Mrs. Overzee, and Mary tended to the infant. During the funeral, however, Mary—along with her accomplice, Mary Williams—stole from the Overzees' house linens, kerchiefs, coifs, collars and smocks, worth about fifty pounds and all made from Flanders' lace. The two ladies tucked the items into their skirts and pillowcases. Mary Williams's husband made the mistake of stashing some of the loot in a tree. The stolen goods were found by two little children, and everyone involved was caught.

In court, Mary Clocker argued that the items weren't stolen at all but simply her deserved payment for her services as a midwife. With his wife dead, Mary doubted that Simon Overzee would compensate her. According to Mary Williams, Mary Clocker had figured that "if we doe not doe it [stealing the goods] wee shall never [receive] anything for our paynes."

Although it was unlikely that the women could have gotten away with publicly using such finery, Mary Clocker apparently didn't care. Her accomplice explained how Mary would "rather than ever hee [Simon

Overzee] shall have them, [she] will burne them & further sayed shee would bury them in a Case in the Grownd." In other words, Mary Clocker would rather destroy the objects than let Simon Overzee keep them.

The court wasn't sympathetic to Mary's testimony. Everyone was found guilty and sentenced to hang.

Fortunately for Mary, the very next day, Marylanders learned of the death of Oliver Cromwell, who had been the Lord Protector of the Commonwealth of England. Cromwell's son Richard inherited his father's position, and in celebration of the new Lord Protector, Maryland's governor pardoned many prisoners—including both Marys.

Mary Clocker's family would continue to live on her and her husband's land for the next two hundred years. Even today, some of the buildings constructed by her grandchildren or great-grandchildren continue to stand in St. Mary's County.

Hannah Cresap: Warrior Woman

ca. 1704–1774, Northern/Western Maryland

Today, the border between Maryland and Pennsylvania is a straight line, famously known as the Mason-Dixon line. However, prior to 1767, the boundary separating the two colonies was nebulous, leading to a series of infractions over who claimed what land. Perhaps most importantly was which colony could lay claim to the growing port of Philadelphia. According to Pennsylvania's charter, the southern border lay north of the fortieth parallel, meaning that Philadelphia should have belonged to Maryland.

Settlers of both colonies began staking out the disputed territory. In 1724, an uneasy truce was created from a royal proclamation, prohibiting more land in the area from being developed until everything could be sorted out. Not surprisingly, the agreement didn't hold much weight, and many unauthorized settlements popped up.

Among the chief instigators were frontiersmen Thomas and Hannah Cresap. Married in 1725, the couple moved north along the Susquehanna River, deep into the controversial region. Apparently Thomas had considered moving to a southern colony, but Hannah wouldn't go. She was a young mother and didn't want to follow his roving spirit.

They set up a ferry service across the river, and Thomas, acting as an agent on behalf of Lord Baltimore back in England, convinced new settlers to purchase their land from him. This in effect made them all Marylanders. However, this didn't sit well with some of his neighbors or with some of his own customers, who had accused the Cresaps of mistreatment.

Infractions reared up regularly in the 1730s between the Marylanders and Pennsylvanians. Scholars refer to this turbulent time by many names, often calling it "Cresap's War." The Cresap faction succeeded in driving out some of the Pennsylvanian settlers and overtook their homes, claiming the stake on behalf of Maryland.

Hannah was as much a part of the battles as her husband. She regularly took up a sword and rode a horse into the fray. Comfortable with a musket, she once defended her home when it was surrounded by Pennsylvanian militiamen.

Another time, she saw a ferry filled with enemies crossing the river. Hannah rode rapidly home, sounding her bugle the entire way and alerting her supporters. Apparently this made the men on the barge rethink their plan. Her quick actions helped save her family's enclave time and again.

In 1736, Pennsylvania authorities sought to arrest Thomas for his troublemaking. The sheriff and deputy of Lancaster County came to the family's house one night to get him. But the Cresaps wouldn't leave so easily, especially not for Pennsylvanians. Thomas shot through the door, wounding Deputy Knowles Daunt. The sheriff asked Hannah for assistance, including a candle so that he could better see and treat Knowles's wound. Hannah refused to help. She told them that not only was she glad that he'd been hurt, but she also wished the bullet had reached his heart, killing him. The words were prescient as Knowles eventually died from the wound.

Unable to take Thomas away, the sheriff returned with reinforcements. With over twenty men, the sheriff again asked for Thomas's surrender. In response to the trouble, a pregnant Hannah started going into labor.

The sheriff's men set Thomas's house on fire, eventually smoking the family out. Their servant, Loughlin Malone, was shot and killed as they escaped the flames. Thomas and some of his men were finally captured and taken to Philadelphia to be held. Upon reaching the city's limits, Thomas remarked, "Damn it…this is one of the prettiest towns in Maryland!"

Following Thomas's arrest, petitions from sympathizing Marylanders were sent to the king. Eventually, in 1738, a treaty was reached, determining a provisional boundary line and a prisoner release. Hannah got back her husband, whom the Pennsylvanians had nicknamed the "Maryland Monster."

Instead of returning to the site of the hostilities, the family headed west, eventually landing outside of Cumberland in the mountains. They set up a trading post and founded Old Town. They even welcomed a young George Washington for a few nights during his surveying expeditions. Thomas became involved with various skirmishes during the French and Indian War. Hannah continued to be his partner, raising their children and undoubtedly fighting back wherever she could. She died in 1774 around the age of seventy.

THE CAPTURE OF JANE FRAZIER

ca. 1750s, Cumberland

Besides becoming the home of Hannah Cresap, Cumberland was also the site of the sensational story of Jane Frazier. Newly wed, Jane settled just outside the city in a log cabin with her husband, John, in 1754. The two had met in her hometown of Winchester, Virginia, before transplanting to Maryland.

In October 1755, John and some neighbors worked to build him a gunsmithing shop. Although heavily pregnant, Jane prepared dinner for everyone. After the meal, she and her servant Bradley rode down to the storehouse to replenish supplies. En route to the storehouse, the duo was attacked by members of the Miami Nation, a Native American tribe out of modern-day Ohio. The attackers killed and scalped Bradley and kidnapped Jane.

Raids had become relatively common in the area, as the French and Indian War had already begun encroaching across Maryland's western frontier. According to Colonel Dagworthy, who commanded Fort Cumberland, "It is supposed that near a hundred persons have been murdered or carried away prisoners by these barbarians, who have burnt the houses and ravished all the plantations in that part of the country." Of course, all these stories are primarily told from one limited point of view—that of the British American perspective, which seemed to customarily forget how they had been the ones taking over land that already served as home to Native Americans.

The *Maryland Gazette* wrote about Jane's capture on October 9, 1755: "By a person who arrived in town last Monday from Col. Cresap's (Oldtown about ten miles from Ivitt's Creek) we are told that last Wednesday the Indians had

taken a man prisoner who was going to Fort Cumberland from Frazier's and the band also carried off a woman [Jane] from Frazier's Plantation which is four miles this side of Fort Cumberland."

Jane described her thoughts on being abducted in an account preserved in *The History of Allegany County, Maryland*, writing:

> *No mortal can describe my feelings at this time. Thus in a moment, without warning, to be torn from husband and home, from all I had held near and dear on earth, and held as a prisoner by the savages—subject to all their savage notions, then it came to my mind that I was to be carried into a western wilderness, uncertain as to when, if ever, I should return. Added to this, I was not in a condition to endure such hardship and fatigue.*

The last sentence refers to the fact that she was pregnant at the time.

However, the Miami Nation treated Jane well during their three-week journey back to Ohio. Surprised, she wrote, "The chief who had me in charge was very kind and assisted me all he could. He would not suffer the other Indians to offer me any harm." Not that the travel was without its own trials. The group suffered food shortages and encountered other Native American groups, but "none of them were allowed to harm me." Once arrived, she was ceremoniously welcomed into the tribe. "Warriors, squaws and children were all running to see the white squaw [Jane] and welcome back their chief and his band, but my captors would not permit them to interfere with me." After her son was born, he was adopted by the group, who mourned with Jane after he died. "Still the Indians were kind to me, and when they saw my child was dead, they cut a hickory tree, peeled off the bark and made a coffin, and wrapping it in some of the clothes they had stolen, they placed it in the coffin they had made and buried it near our town in their own burying ground," she recalled.

Additional raiding parties brought back more kidnapped people, including a tanner from Pennsylvania. While another raid was being planned by members of the tribe, so was Jane plotting her own venture: escape. She worked with the two men. "We now concluded this would be the best time to gain our liberty, so obtaining a small amount of ammunition we gathered up our old gun and some provisions and left." The trio successfully ran away from the tribe. All in all, Jane had been with the Miami Nation for about a year.

Although the three traveled together for a while, Jane eventually decided to branch out on her own. The night before, the men had shot a turkey and ate too much. That morning, they were unable to travel. Afraid that her

captors would catch up with them as the men lay about, Jane decided, "I would not consent to stay with them, choosing rather the chances of the wilderness than the danger of captivity again, I started on alone. Again I experienced untold privations, having to live on vegetables and the bark of trees and climbing up a tree or down in a hollow to be secure from wild beasts at night." Even though she was in unfamiliar territory and without food, she found a trail back to Maryland after about nine days. By following the trail for another two days, she was finally able to reconnect with friends in Old Town.

During her time away, John had given up hope on Jane being alive and had remarried. While the news undoubtedly troubled Jane, she continued home unabated. As word spread of her return, a ragtag parade of locals and friends joined her procession back to John. When she arrived, John immediately picked her up and shouted, "The lost is found; the dead is alive!"

John's new wife amicably left the house, supposedly returning after giving birth to his child. According to local lore, she claimed that she didn't want the baby and gave him to Jane, who raised the boy as if he had been her own. The reunited couple went on to have two daughters as well.

During the French and Indian War, John received a request from Colonel George Washington asking him to join up with them in Pennsylvania. The entire family followed John, never returning to Maryland again.

Jane's log house continued to stand until the twentieth century but was razed in the 1960s, although a marker remains. One of her descendants, Ruby Frazier Frey, wrote a fictional account of Jane's astonishing story in the 1946 book *Red Morning*.

SARAH WILSON: THE FAKE PRINCESS

ca. 1770s, Frederick

In 1771, William Devall of Bush Creek in Frederick County advertised, searching for his runaway indentured servant, Sarah Wilson. He warned readers of the *Pennsylvania Gazette* that Sarah had "changed her name to Lady Susanna Carolina Matilda" and "made the public believe that she was his Majesty's sister." He went on to describe her in detail, pointing out that she "has a blemish in her right eye, black roll'd hair, stoops in the shoulders, [and] makes a common practice of writing and mark[ing] her cloaths with

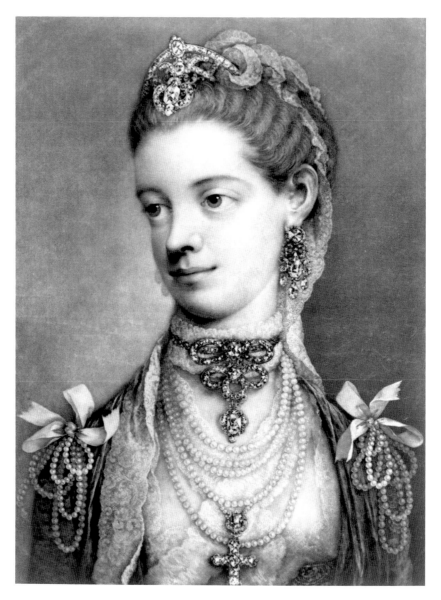

Queen Charlotte. *Author's collection.*

a crown and a B." According to his description, Sarah was pretending to be English royalty. He offered a reward for her return.

The story of Sarah Wilson dances on the edge of incredulity but nonetheless happened. Born around 1750 in England, Sarah became the aide to Caroline Vernon, a maid of honor to Queen Charlotte. Under

Caroline's employ, Sarah not only learned the ways of the aristocracy, but she also managed to steal several of her employer's fineries. In the British *Gentleman's Magazine* in 1773, it was described how Sarah had "found means to be admitted into one of the royal apartments, took occasion to break open a cabinet, and rifled it of many valuable jewels."

Although she was caught and sentenced to death, Caroline took pity on her. Instead, she had Sarah shipped out to the New World, where she ended up sold as an indentured servant to William Devall in Maryland.

Not that it took long for Sarah to escape. Soon, she was traveling south, pretending to be Princess Susanna. "She had carried with her clothes that served to favour the deception, and had secured a part of the jewels, together her majesty's picture," reported the *Gentleman's Magazine*. Somehow, Sarah managed to leave England with additional stolen goods, including a miniature portrait of Queen Charlotte—all of which helped convince others of her ruse. The *Magazine* continued, recounting how "she travelled from one gentleman's house to another under these pretensions, and making astonishing impressions in many places, affecting the mode of royalty so inimitably, that many had the honour to kiss her hand."

She offered "promotions of all kinds in the treasury, army, and the royal navy." Perhaps the people she encountered were so in want of these opportunities that they were willing to overlook how ridiculous a situation she created. What princess travels across the colonies, unexpected and alone?

Not that she was always by herself. Stories connect her with "Tom Bell," the alias of Patrick O'Conner, who defrauded people while pretending to be an Irish merchant. The Historical Society of Pennsylvania notes that "for a short time, he introduced himself as 'Mr. Edward Augustus Montague,' a 'gentleman of fortune,' and betrothed lover of the Princess Susannah Carolina Matilda." Sarah used several additional identities in her travels, including pretending to be the Marchioness of Waldengrave and the Princess of Cronenburgh.

William Devall caught his wily servant, but only for a short period before she escaped once more. In 1775, Sarah married Captain William Talbot, of His Majesty's Seventeenth Regiment of Light Dragoons. While she never served time for any of her crimes, marriage must have ended her antics, as she slips out of the annals of history, much as she had from William Devall.

Chapter 2
MARYLAND'S SO-CALLED WITCHES

While most people today associate colonial witchcraft trials with Salem, Massachusetts, Maryland had its fair share of accusations, although the colony never endured a similar mass hysteria. In fact, the majority of residents taken to court for being witches were generally acquitted of the charges. Apparently, the state's officials were able to tell that in most of these cases, the cry of "witchcraft" was nothing more than upset neighbors looking to defame someone they didn't like.

Records exist for at least six trials in Maryland between 1626 and 1712. The majority of those accused were women, but not all. John Cowman was found guilty of affecting "upon the body" of an indentured servant named Elizabeth Goodale around 1675. However, when John sought clemency, his request was approved—only after he was carried "to the Gallows, and that the rope being about his neck, it be there made known to him how much he is Beholding to the Lower house of the Assemblie." Essentially, the authorities attempted to scare him straight.

In 1656, Judith Catchpole was accused of using witchcraft to kill her newborn child while coming to Maryland aboard the *Mary and Francis*. The five justices assigned to her trial didn't give the story much credence. Interestingly, they brought together a jury composed entirely of women. When the female jury determined that Judith had not given birth in the first place, she was released.

Not everyone was so lucky, however.

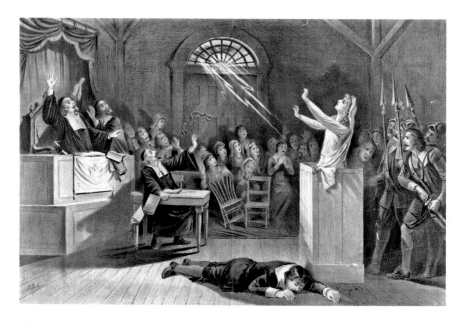

"The Witch Trial." *Library of Congress.*

Two early immigrants—Mary Lee and Elizabeth Richardson—were both hanged at sea en route to Maryland from England. In both instances, the ships encountered extended storms during their voyages. The women became scapegoats to the sailors' frustrations. However, both cases were deep in international waters, where the laws of the land could be easily skirted.

Mary Lee came aboard the *Charity* in 1654. When the vessel encountered a horrible storm, the crew considered abandoning ship. However, they determined that the storm wasn't natural but Mary's fault. She was searched for "witch's marks," which could be almost any sort of blemish or other skin imperfection. Not surprisingly, the sailors found what they sought. She was taken below deck and searched again in the morning. After supposedly confessing, she was hanged and her body and goods tossed into the sea.

Elizabeth Richardson suffered a similar fate in 1658. George Washington's great-grandfather John complained about Edward Prescott, the owner of the ship on which Elizabeth died. He alleged that Edward was responsible for Elizabeth's hanging. However, Maryland's proprietary governor, Josias Fendall, required John Washington to testify in person, which he was unable to do, living out in Virginia. In fact, he had received only a few days' notice before the trial was scheduled on October 4, 1659. Without anyone else willing to testify against Edward, the owner was acquitted of murder.

MARYLAND'S SO-CALLED WITCHES

REBECCA FOWLER: THE UNLUCKY WITCH

ca. 1630s–1685, Calvert County

While midwife Mary Clocker had been lucky to have her sentence commuted from a death sentence, another former indentured servant, Rebecca Fowler, was not so fortunate. In 1685, the Calvert County widow was sentenced to die for being a witch.

Rebecca had likely come to Maryland in 1656 as Rebecca Parrot. She worked for a while as an indentured servant for Henry Cox. Then, after completing her service, she married John Fowler, a fellow indentured servant. They had at least one child, a boy named Richard. In 1683, they purchased a plot of land called "Fowler's Delight" in modern-day Prince George's County.

According to the trial records, Rebecca Fowler was accused of "having not the feare of God before her eyes but being led by the instigation of the Divell certaine evil & dyabolicall artes called witchcrafts, inchantments charms & sorceryes then wickedly, divelishly and feloniously at Mount Calvert Hundred & several other places in Calvert County." Apparently, Rebecca cast some sort of evil spell against a young man named Francis Sandsbury on August 31, 1685.

Supposedly as a result of her efforts, his body "very much the worse, consumed, pined & lamed." The language used indicates that Francis was injured. He may have believed that Rebecca cursed him.

She was taken to St. Mary's City and kept in a cold jail cell with three additional women. She would have been forced to sleep on the floor with only a little straw for comfort. Fortunately, her turn came quickly, starting nearly one month after the accusation on September 29. She requested a jury trial to the six justices. It started on Friday, October 2. She didn't have a lawyer. Two of the jurors selected had connections to the John Cowman witchcraft case a decade earlier.

While Francis was a man, he was also an indentured servant, one of the lowest rungs of society. Rebecca was a landowner, providing her with more political power. She may have thought that her status would have given her some protection from the charges. If Rebecca also knew that earlier trials in the colony had always acquitted the so-called witch, she may have felt some assurance that she would prevail in court.

Unfortunately, Rebecca was found guilty.

Some scholars, such as William Cooke in his book *Witch Trials, Legends, and Lore of Maryland*, speculate that the trial was a ruse to showcase the court's

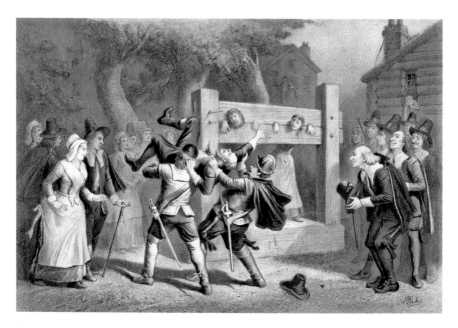

Suspected witches in stockades. *Library of Congress.*

authority, as the governor had publicly lampooned the court's power. While this had nothing to do with witchcraft, it would suggest that Rebecca had become a pawn in the middle of their struggle.

Either way, she was hanged on October 9, 1685.

VIRTUE VIOLL: THE LAST WITCH

ca. 1700s, Talbot County

Fortunately, Rebecca Fowler's guilty verdict didn't lead to a deluge of madness against so-called witches. Only a year later, the court acquitted Hannah Edwards of similar accusations. In February 1686, Hannah supposedly used witchcraft to injure Ruth Hutchinson, causing her to be "consumed, pined and wasted"—a similar accusation to the one Rebecca had faced. The use of the word "wasted," however, suggests that instead of being injured, Ruth was more likely taken ill. Whatever the case, it was not a fatal disease.

Hannah ended up in the same jail cell as Rebecca had been housed, awaiting trial. If she knew about Rebecca's case and sad verdict, she may

have been in fear for her life. Her trial happened on April 30. Two of her jurors and two of her grand jurors had also been involved with Rebecca's trial. This couldn't have inspired confidence in Hannah. Somehow, however, she received the opposite verdict and was acquitted. Unfortunately, since there aren't surviving transcripts, it is difficult to know the exact details of what made the two cases end differently.

The last witchcraft trial in colonial Maryland occurred in 1712, when Virtue Violl, a spinster from Talbot County, was arrested for being a suspected witch.

Virtue was taken across the Chesapeake Bay to Anne Arundel County for her trial. The language of her trial records sounds similar to Rebecca's. Virtue was accused of "being seduced by the devil most wickedly, & diabolically did use practice & exercise witchcraft whereby & wherewith she did waste, consume and pine the body of a certaine Ellianor Moore." The use of the word "waste" instead of the word "lame" in Rebecca's indictment suggests that Ellianor may have fallen victim to a wasting disease. Virtue also apparently turned Ellianor speechless.

Fortunately for Virtue, she ended up with a better fate. Almost thirty years to the date of Rebecca's hanging, Virtue Violl was found not guilty.

MOLL DYER AND ELLY KEDWARD: MYTHIC WITCHES

ca. 1697, Leonardtown and Burkittsville

Today, there are a few common tales floating around about other colonial Maryland witches. According to legend, Moll Dyer lived around 1697 in Leonardtown in St. Mary's County. Townsfolk bearing torches stormed Moll out of her home on a cold winter night, accusing her of cursing their town. She escaped to the woods, where exhausted, she fell upon a large rock and froze to death. After her corpse was pried loose, her handprint remained embedded in the rock.

In 1972, a rock was identified as hers and moved from the woods to the front of the courthouse. A street and a creek have also been named in her honor. Interestingly, there is no other evidence that Moll ever existed. Perhaps that was her greatest spell: being remembered while also fading away.

Perhaps the most famous Maryland witch tale is that of Elly Kedward. The story goes that Elly lived in Blair (now Burkittsville) in the late 1700s,

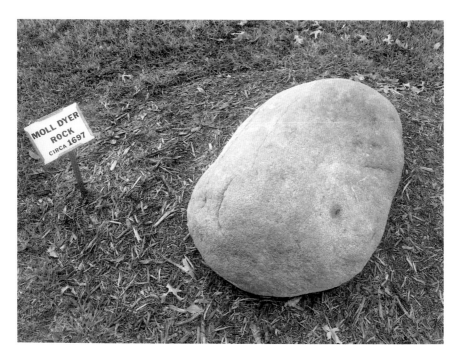

Moll Dyer Rock, Leonardtown, Maryland. *Author photo.*

where the locals killed her for practicing witchcraft. Apparently, her ghost returned the following year to kidnap all the children in the area.

It's a great legend except for the fact that it's all fake.

The saga of the fictional Elly Kedward was developed for the 1999 movie *The Blair Witch Project*. As part of the marketing material for the film, a website was started featuring Elly's story.

Although she never existed, the Maryland Historical Society still fields inquiries from people seeking resources about her. It now has a resource—the movie itself has been added to its collection.

WARTIME WOMEN

Soldiers, Smugglers and Spymistresses

In 1781, the *Maryland Gazette* in Annapolis published a poem entitled "The Attempt Is Praise." An anonymous poet, identified only as a soldier, praised "the sister angels of each state," with whom he credits "inspiri[ng] and enobl[ing]" the Patriots fighting for American freedom during the Revolutionary War. He sees Maryland women as "mirrors of virtue" and that the soldiers are "cheer'd by such gifts, and smiles and pray'rs from—you," which he considers "more precious treasure in the soldier's eye, than all the wealth Potosi's mines supply." (Potosi is a reference to the silver mines of Bolivia.)

The poet closes his poem by writing:

> And thus the future bards shall soar sublime,
> And waft you glorious down the stream of time,
> The breeze of panegyric swell each sail,
> And plaudits pure perfume th'encreasing gale;
> The freedom's ensign, thus inscrib'd shall wave—
> "The patriot females who their country save,"
> Till time abyss, absorb'd in heav'nly lays,
> Shall flow in your eternity of praise.

Throughout Maryland's history, women have played a significant, albeit often forgotten, role in war. They have served as spies, suppliers, smugglers and soldiers. They have risked their lives to fight for what they believed in and the right to take that stand.

MARY PICKERSGILL AND GRACE WISHER:
STAR-SPANGLED SEAMSTRESSES
1776–1857 and ca. 1800s, Baltimore

War exploded in 1812 in response to rising tensions between America and England. By the spring of 1813, skirmishes had broken out along the Chesapeake Bay, bringing the War of 1812 to Maryland.

In Baltimore, Mary Pickersgill oversaw the construction of the American flag that flew over Fort McHenry. The enormous flag included fifteen two-foot-wide stripes and stars—a monumental task to undertake. However, she did not create the flag alone, working with her daughter Caroline; elderly mother, Rebecca Young; and Grace Wisher, her thirteen-year-old African American apprentice.

Although technically free, Grace had been bound to the Pickersgills in 1809 by her mother, Jenny Wisher. It was likely that Jenny had been unable to take care of her young daughter, so she placed Grace into the apprenticeship so she could learn new skills and one day become independent. Interestingly, this arrangement involved only women—Jenny

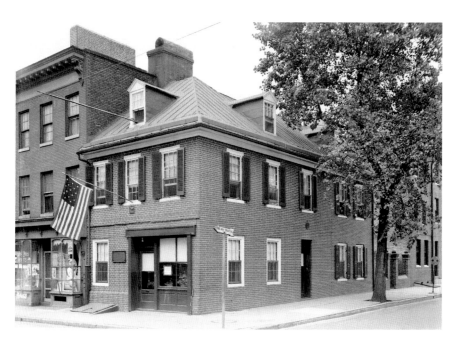

Flag House, Baltimore, Maryland. *Library of Congress.*

agreeing to the contract, Mary managing the child's work and Grace serving as apprentice.

Little is known about Grace, which is not surprising, given that little is known about most free blacks of the time, let alone free black women. Baltimore was home to a significant number of free black people, but they were generally treated as less than second-class citizens. Records from the time often overlook their contributions to city life, let alone their assistance to the war effort.

The giant flag that Grace helped sew withstood British onslaught and inspired Francis Scott Key to pen "The Star-Spangled Banner." The iconic piece is now housed in a special gallery at the Smithsonian's National Museum of American History. The home that these women shared stands today as the Star-Spangled Banner Flag House, and Grace's story was recently featured in the neighboring Reginald F. Lewis Museum of Maryland African American History and Culture.

KITTY KNIGHT: GEORGETOWN'S GUARDIAN
1775–1855, Georgetown

In 1813, the British made deeper inroads into Maryland's Eastern Shore. They encountered strong resistance from the residents of Georgetown, where locals fired on the soldiers. Enraged by their actions, the British raided the area, setting houses on fire and destroying granaries. Led by Admiral George Cockburn with his Royal Marines, they looted and overran both the village and neighboring Fredericktown.

However, when they reached a house atop a hill, they were stopped—but not by an army of soldiers. Instead, they were held at bay by a single young woman.

Catherine "Kitty" Knight, daughter of prominent citizens John Leach and Catherine Matthews Knight, pleaded with Admiral Cockburn to save the hilltop home, where an elderly, infirm woman lived. "Before I got to the top of the hill they had set fire to the house in which this old lady lay," she later recalled. "I immediately called the attention of the Admiral to the fact that they were about to burn up a human being, and that a woman, and I pleaded with him to make his men put the fire out."

While they listened to her request, the men proceeded to the next house to continue their destruction. Kitty pointed out that the wind would carry

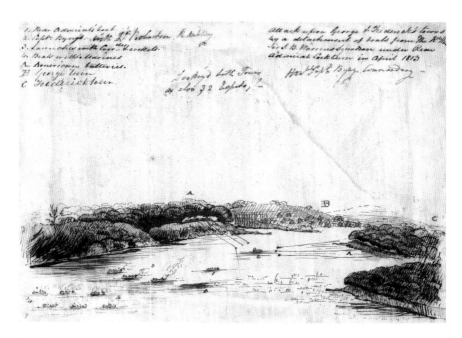

Attack on Georgetown, Maryland. *Library of Congress.*

Kitty Knight house. *Library of Congress.*

the blaze right back to the poor woman's home, nullifying their efforts. The admiral ordered his men off, but the fire had already taken root. The British did nothing to clean up their work, so Kitty set about stamping out the fire herself. Unfortunately, Kitty's own house had already fallen victim to their efforts. Later on, however, she went on to purchase the one she had saved.

The story was recounted in her obituary in 1855. The newspaper wrote glowingly of her intelligence and bravery. Although Kitty never married, she was a known beauty, having even caught the eye of a young General Washington during a dance in Philadelphia when she was a young woman in the 1700s.

In 1899, a local steamboat crossing the Sassafras River was renamed the *Kitty Knight* in her honor. Today, the saved home is part of the Kitty Knight Inn, which serves as a restaurant and hotel in Cecil County. Kitty is buried nearby in the Knight family plot of the cemetery of St. Francis Xavier Shrine.

Matilda O'Neil: The Heroine of Havre de Grace
ca. 1797–1800s, Havre de Grace

Like Kitty Knight, Matilda O'Neil, daughter of lighthouse keeper John O'Neil, also had a memorable encounter with Admiral George Cockburn. When the British encroached on the nearly defenseless Havre de Grace in 1813, Matilda's father, John, attempted to protect the town. He raced up to one of the only two batteries along the river. Apparently, his fellow militiamen retreated, leaving John alone in high fight. Undeterred, John used all four of the battery's cannons against the mighty British flotilla.

Admiral Cockburn, on the other hand, commanded at least fourteen ships and four frigates. It would not be a fair fight, but John refused to give up. The recoil of the final cannon injured John's leg. Nonetheless, he managed to crawl his way to the nearby St. John's Church to hide, carrying two muskets with him. The British caught John and took him aboard the *Maidstone*, their flagship.

Upon hearing of her father's capture, sixteen-year-old Matilda immediately began pushing for his release. She ran down to the waterfront to find out where her father had been taken. She threatened to row out alone across the Susquehanna River if she needed to. Accompanied by her attorney, Abraham Jarrett, and another woman, she rowed out and boarded

the *Maidstone*, knowing that she could easily be risking their, hers and her father's lives. However, Matilda was very much her father's daughter and refused to back down, even against great odds.

Unfazed, she valiantly argued for her father's release. She succeeded in acquiring Admiral Cockburn's audience, where she pleaded for her father's safety. Cockburn replied that they had only peaceful intentions in passing Havre de Grace, although they had already destroyed several settlements and ironworks. He noted that John was not in uniform when they found him, indicating that he wasn't a soldier himself. There were different punishments for military men officially fighting on behalf of the state versus renegade civilians. As a result, Cockburn believed that John should be hanged for his "overt acts against armed forces of His Britannic Majesty."

Matilda beseeched him, explaining how the State of Maryland hadn't provided for her father's militia's uniforms, so they didn't have any, but she offered to bring the paperwork proving that he was indeed a commissioned soldier.

Cockburn gave her one hour.

She rowed back to the shore and ran home. Time was running out, and the house had been damaged during Cockburn's so-called peaceful tour. Nonetheless, Matilda managed to procure the paperwork. Scurrying back, she made the deadline.

Perhaps impressed by her gumption, the admiral agreed to release her father.

When John was freed the next day, Cockburn presented Matilda with his gold-lined snuffbox. According to legend, he said, "Keep this for remembrance of Admiral George Cockburn, who admires loyalty and bravery in his enemies as he rewards the same virtues in his men." Matilda accepted the trinket. The piece became an heirloom, passed down through her family.

Today, a memorial stands to the tenacity of Matilda and her father—an original War of 1812 cannon, inscribed with the story of their heroism.

CLARA GUNBY AND SALLIE POLLOCK: SPYMISTRESSES FOR THE SOUTH
1839–1890, Salisbury, and 1847–1890, Cumberland

During the majority of the Civil War, Maryland remained under Union occupation, forcing it out of Confederate hands. Some, like Barbara Fritchie (discussed in the Introduction), supported this action. However, many of its

resident women held pro-Southern sympathies, so for every Barbara Fritchie, there was a Clara Gunby, who refused to walk beneath a Union flag in Salisbury on the Eastern Shore. She was arrested for her defiance and taken to Fort Monroe, Virginia, after refusing to take an oath of allegiance to the Union. While imprisoned, she met Amy Francis Cormick, who convinced Clara to take a letter to the Confederate president, Jefferson Davis, after Clara was released during a prisoner exchange. On July 13, 1864, she was able to get the letter to him at the Spottswood Hotel in Richmond, Virginia. Clara recounted the experience in her diary, writing:

> *In a few minutes he came down. He took a chair very near me. I told him that I met Mrs. Amy Francis Cormick in prison at Fort Monroe; that I could not vouch for the truthfulness of the message, as the lady was a stranger to me. He said he knew her and would trust to every word she uttered…Mrs. Cormick has discovered previous to her arrest that one John Reed of Charleston, South Carolina was a Federal spy…When I told [President Davis] of [Amy Cormick's] suffering, of her small furnace like room, and bread and water allowance, I saw a tear gather in his eye as he feelingly exclaimed would to heaven I could relieve her.*

According to her diaries—now housed at the Edward H. Nabb Research Center for Delmarva History and Culture at Salisbury University—Clara so impressed Jefferson Davis that he offered to connect her with her brothers fighting for the Confederates, as well as a position as a clerk. She accepted. Clara returned to Maryland after the end of the Civil War and began pursuing a different passion: artwork. She became a well-respected painter with her work appearing in Baltimore and New York. She also went on to marry before passing away in 1890.

Far across the state, another young woman also began smuggling information for the rebels. In 1861, Union troops began occupying Sallie Pollock's hometown of Cumberland, Maryland. Although she was only fourteen at the time, she began secreting letters across the Potomac River to her Southern allies. She continued passing information for three years.

Through an intermediary, Sallie learned that a man named Ira Cole wanted a package taken to Virginia. She agreed to meet him at the Revere House downtown in April 1864. Because they had never met before, Ira told Sallie that he wasn't certain he could trust her to do the job he wanted: smuggling information across state lines. She asked him how she could win that confidence. Ira suggested she prove that she really carried letters from others.

Sallie agreed, showing him a couple letters from other Confederates. The letters were enough to convince Ira, and he consented to her taking across his materials, which had been stored elsewhere for safekeeping. En route to the package, however, Ira revealed his true allegiance; he was actually a Union agent working undercover. He arrested Sallie, whereupon he discovered that she also carried letters to high-ranking Confederate officials, including General Robert E. Lee and President Jefferson Davis.

Found guilty by a military tribunal, Sallie was supposed to be imprisoned until the end of the war but ended up serving only seven weeks instead. Union secretary of war Edwin Stanton called for her early release, on the condition that she stop carrying materials for the Confederates.

Sallie consented to the conditions. She went on to marry twice and have multiple children but never encountered military trouble again. Like Clara, she died in 1890.

EUPHEMIA GOLDSBOROUGH: CIVIL WAR NURSE
1846–1896, Baltimore

While Sallie was engaging in spying activities out in western Maryland, Euphemia "Effie" Goldsborough offered her family's home as a haven for Confederates in Baltimore. Her house became an important stop for Southern soldiers north of the border, as well as a port of call for blockade runners secreting supplies back and forth over enemy lines.

However, when Effie learned about the Battle of Antietam, she headed out to Frederick to become a nurse. From Frederick, she then sought to help with the wounded at Point Lookout, where Confederate prisoners of war were confined. After hearing about the thousands hurt at the Battle of Gettysburg, Effie trekked to a ramshackle hospital set up at modern-day Gettysburg College (then Pennsylvania College).

While there, she discovered that many of the wounded Confederates lacked proper clothing. Effie began smuggling clothes to the patients there. One time, she hung boots by their laces beneath her hoop skirt. Heading back to the hospital, a Union soldier offered to help her into a waiting ambulance. Unable to politely turn him down, Effie was forced to accept his gesture. She carefully ascended into the ambulance, hoping that the boots wouldn't bang against the side of the vehicle

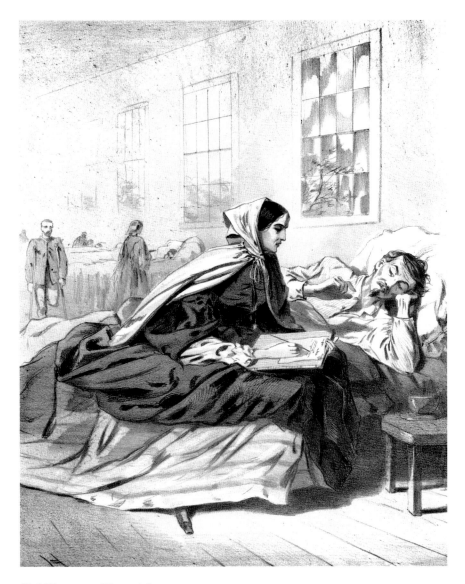

Civil War nurse. *Library of Congress.*

and reveal her illegal activity. Fortunately, she succeeded, and he never suspected anything.

Her sister Mona remembered how Effie had worked tirelessly to give aid to the wounded Lieutenant Colonel Waller Tazewell Patton. He had lost his jaw during Pickett's Charge in the heat of the Battle of Gettysburg. Mona later wrote:

The surgeons in charge decided that it was imperative to place Colonel Patton in practically a sitting posture to prevent suffocation. Being shot through the lungs, and unconscious, it was impossible to save his life unless he could be propped up, and there was absolutely nothing to be had to prop him. Seeing the difficulty, Miss Goldsborough decided to offer herself as the necessary agent. Accordingly, she seated herself on the bare floor, feet extended, and the surgeons tenderly placed the dying officer against her back and secured him there. She sat there, still as a wooden image, never daring to move lest the slightest motion bring on a hemorrhage and death ensue.

Although he did not survive the injury, Effie's efforts offered the mortally wounded officer some dignity and showcased her tireless work to provide whatever support she could to her patients. While Effie had come to Gettysburg to nurse Confederate soldiers, she took on the task of treating the wounded from both sides equally. However, her sympathies remained with the South. After returning to Baltimore, Effie and her family continued smuggling letters and supplies.

In November 1863, Effie was arrested on suspicion of treason. She was escorted by a military guard to Virginia and exiled from the Union until the end of the war. Although alone in Richmond, Effie was treated like a returning royal for her role in treating Confederate soldiers and smuggling supplies. While there, she worked at the treasury in the mornings and continued serving as a nurse in the afternoon until returning to Maryland when the war ended.

ANNA ELLA CARROLL: LINCOLN'S SECRET GENERAL
1815–1894, Somerset County

Anna Ella Carroll was born for politics. Her grandfather Charles Carroll of Carrollton was a signer of the Declaration of Independence. Her father, Thomas King Carroll, was elected Maryland's governor in 1830. She joined him in Annapolis, leaving behind her childhood home of Kingston Hall on the Eastern Shore. While only a teenager at the time, Anna availed herself of the experience to meet a who's who of burgeoning political names. Unlike other young women, though, she wasn't interested in these men as potential spouses but instead cultivated collegial friendships with them. As she grew

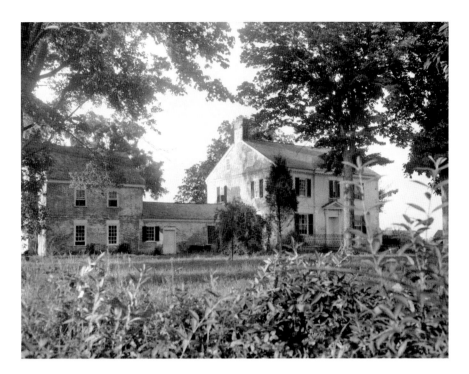

Kingston Hall. *Library of Congress.*

into adulthood, Anna made a business from these relationships, serving as their social secretaries. All the while, however, she worked on fashioning a career as a pamphleteer, writing primarily for the railroad industry but also for the navy and other political interests. She served as a lobbyist and promoter for various political figures. She became sought after for her media savvy—a nineteenth-century "spin doctor."

By the early 1850s, she had become deeply enmeshed with the Whig Party and strongly supported Millard Fillmore's attempt to win a second presidency. Using pseudonyms and initials to disguise her sex, Anna wrote several articles and pamphlets in his support. At the same time, she also published her first two books: *The Great American Battle* and *The Star of the West*. Anna corresponded regularly with Millard, and he expressed appreciation for her work. Although he failed in his bid for reelection, he did win Maryland. Indeed, it was the only state where he claimed victory.

As the Whig Party began dissolving mid-decade, Anna aligned herself with the American Party—also known as the Know-Nothings. The name arose from their secretive meetings. If participants were asked about what transpired, they'd simply answer how they "knew nothing." The American

Party's values reflected Anna's own complex set of personal politics. Both remained loyal to the Union with mixed feelings on slavery. Their stance on Catholics and immigrants, however, was clear-cut. They saw both groups as intruders, trampling on a tradition of British Protestantism in the country.

Anna, however, cannot be boxed into a simple political stereotype. She was a strong Unionist in a state increasingly divided over the issue of slavery. Born into a slave-owning family, she released her own slaves but did not push widely for abolitionism, instead favoring colonization and limited emancipation. A resolute Protestant, she published regularly against Catholicism, believing the religion to be corrupt and malignant. An educated and powerful writer with friends in high places, she worked behind the scenes in support of various politicians but never sought for increased women's rights.

By the early 1860s, the American Party had fractured and fallen apart. Anna attempted pushing John Minor Botts to be considered as a nominee for president in 1860. A Unionist from Virginia, she thought his more moderate stance would prevail, but he was unable to even capture his own state's support. When the Republican Abraham Lincoln won the office instead, Anna moved to D.C. Although she had never been a Republican, she worked tirelessly to promote Lincoln's dream of maintaining the Union, especially Maryland. As states like South Carolina and Virginia left the Union, she lobbied Maryland's governor, Thomas Hicks, to keep the state legislature from voting on secession. It never did.

Early into the Civil War, Anna made a trip to St. Louis, using the cover of visiting relatives and friends. In reality, she was gathering intelligence for the government on the western front of the war's theater. She knew that generals were considering ways to wrench control of the mighty Mississippi River from Confederate hands. However, after talking with a riverboat pilot, Anna came to the conclusion that taking the Mississippi was impossible. According to her, the pilot told her that

> *gunboats were not suited to fight on the Mississippi, on account of its strong current; that there were a great many positions on the Mississippi that the enemy could make as strong as Columbus* [Kentucky]; *that they would be fortified as our fleet descended, so that innumerable battles must be fought, and it would take years to open that river; and this, he said, was the belief of every pilot connected with the expedition.*

Agreeing with his assessment, Anna asked the pilot about the possibility of other rivers, including the Tennessee River. He agreed that this was a much

better choice. After their discussion and conducting considerable research in the city's Mercantile Library with the help of a Union-supporting librarian, Anna wrote up her recommendations to divide the South in half by taking the Tennessee River. She sent her findings to both Attorney General Edward Bates and Assistant Secretary of War Thomas A. Scott. She insisted:

> *It is not the Mississippi but the Tennessee river…On* [the Mississippi] *river many battles must be fought and heavy risks incurred before any impression can be made on the enemy, all of which could be avoided by using the Tennessee River. This river is navigable for middle class boats to the foot of the Muscle Shoals in Alabama, and is open to navigation all the year, while the distance is but two hundred and fifty miles by the river from Paducah, on the Ohio. The Tennessee offers many advantages over the Mississippi. We should avoid the almost impregnable batteries of the enemy, which cannot be taken without great danger and great risk of life to our forces, from the fact that our boats, if crippled, would fall a prey to the enemy by being swept by the current to him, and away from the relief of our friends.*

She continued her letter by making the argument that taking the river would "cut the enemy's line in two, by reaching the Memphis and Charleston railroad, threatening Memphis, which lies one hundred miles due west, and no defensible point between; also Nashville, only ninety miles northeast, and Florence and Tuscumbia, in North Alabama, forty miles east." She also pointed out that it would help in supplying an attack against Mobile and figured that their efforts would be supported by loyalists in Tennessee, of which the eastern part of the state had many.

It was a solid plan, and one that Assistant Secretary of War Thomas Scott supported. But there was a problem. No general wanted to implement a plan that was not only offered by a civilian but a female one at that. Thomas helped Anna conceal her identity in promoting the plan. The Union followed the plan's tenets in February 1861 and enjoyed some of its first victories in the war, taking both Forts Henry and Donelson.

Anna continued advising the government on additional plans, such as the best method for taking Vicksburg, Mississippi, in 1863. At first, General Ulysses S. Grant ignored her advice for an overland assault and attempted to take the city from the Mississippi River. When he finally gave up and changed his strategy to match hers, Vicksburg fell.

She also consulted Lincoln on emancipation, which she didn't believe the Constitution allowed for without an amendment passed. In late 1861, she

produced a pamphlet entitled *War Powers of the General Government*, wherein she suggested that slaves in the Confederacy could be freed, as they were considered property that the government could seize. However, the action, she wrote, would be "temporary…since it is a power springing out of war, it must necessarily expire with the war." Overall, Anna didn't support the Emancipation Proclamation because she wanted to retain the support of Unionists in the Southern states. Although she freed her own slaves even before the start of the Civil War, she apparently felt that this was a personal decision, not a governmental one.

Anna continued to write prolifically throughout and following the Civil War. After Lincoln's assassination, she criticized President Andrew Johnson for "reinstat[ing] the rebel state governments for the purpose of securing his own [re]election to the Presidency." However, for all her efforts, she was rarely and poorly paid. Historians argue over whether Anna's writings truly had an effect on government and military leaders and how much they helped the Union win the Civil War. But if her writings were purely coincidental to existing military strategy, that does not lessen how remarkably "on the nose" they ended up being. She did receive $1,250 from Secretary Scott and another $750 from the War Department for serving as a spy, but her request for $5,000 for creating three pamphlets during the Civil War did not receive positive reception in the full Congress—although the majority of committees that considered her requests were in support of paying her.

Anna Ella Carroll passed away in 1894 of natural causes. She was laid to rest in her family's plot at Old Trinity Church in the appropriately named Church Creek, Maryland. Before she died, the growing suffragist movement took Anna's case for remuneration for her publications. While it was unsuccessful in getting Congress to fund her, she became part of the argument for women's greater involvement in American political discourse, helping pave the way for future efforts.

MARGUERITE HARRISON: WORLD WAR I JOURNALIST-SPY
1878–1967, Catonsville

Marguerite Harrison may not have been a soldier, but she was something just as dangerous: a journalist. Born Marguerite Elton Baker in 1878, she was raised in a well-to-do Catonsville-area family. However, in 1915, her

Reporters at Fort Meade, Maryland. *Library of Congress.*

affluent life crumbled: her husband died, leaving her with a teenage son; her mother also passed away; and her father lost the family fortune. With few options to sustain herself, she sought a position with Baltimore's *Sun* newspaper. Amazingly, they immediately hired her as an assistant society editor, although she had no journalism background. But Marguerite was smart, quick and never willing to let things simply go. She was soon promoted, becoming a music and theater reporter.

When America entered World War I in 1917, Marguerite wrote how "bursts of cheers" rang across the newsroom. Soon, she began reporting on the state's war preparedness and worked to increase public support for the conflict. While the *Sun* may have supported American entry into the "war to end all wars," many Marylanders were leery of getting involved with such a large and costly effort that seemed more about the issues between other countries, not theirs.

She wrote stories on modern camouflage techniques using artists and Hollywood set painters, went undercover as a Bethlehem steel worker to "rouse public interest in America's colossal task of equipping an army of

three million men and transporting them overseas" and tried her hand at a series of jobs using a fictional identity as a widow. "I secured over 20 jobs," she wrote, "paying from $2.50 to $25 a week, and ranging from waitress to chorus girl." Her articles showcased how women were capable of replacing any men leaving for the war.

In 1918, Marguerite's patriotic fervor and inherent journalistic curiosity led her to Europe. Since she had been denied official permission as a journalist, she used a different means of entry, joining the Military Intelligence Division (MID) of the U.S. Army. Although the war ended before she left America, MID sent Marguerite to gather information on postwar Germany. Cultural information, such as how supplies and food were lasting, public sentiment and other data, would help the army negotiate a treaty. The *Sun* approved of Marguerite's discreet activities, especially as they wanted to report on how Germany was handling defeat.

Under the guise of screening films in France, Marguerite headed across the Atlantic. In January 1919, she reached Germany, the first female American correspondent to arrive. She traveled by herself, remarkably freely.

Berlin was embroiled in riots, led by German communists. Several radical political groups were attempting to curry widespread favor in the midst of the uproar and leadership void left by World War I. Marguerite arrived as "bullets bounced on the pavement and ricocheted from the walls of the buildings around us." After three days, the revolt failed.

While in Germany, Marguerite attended salons and met with all types of people: the socially elite, artists and political firebrands. "I rarely had a half-hour to myself during the day. My life was one of continual activity and tension. I was obliged to make and maintain contacts with every political party. I could not afford to overlook any happening great or small that would throw light on conditions in Germany or the secret machinations of this faction or that." In addition to observing the political climate of the country, Marguerite also undertook missions for MID, including monitoring criminal suspects.

Marguerite returned to Baltimore in July 1919. She ran a series of articles on postwar Germany, with many making the front page. After such adventures, returning to the theater and music section of the paper was impossible. She craved excitement and unearthing little-known stories. Having experienced postwar Germany, she was soon drawn to another war-torn country rarely explored by Americans: Russia.

She went on behalf of both the *Sun* and MID but without any official paperwork. The MID didn't want to be easily linked to her activities, so getting into Russia was entirely on Marguerite.

Although Russia was at odds with its neighbor Poland, Marguerite felt that was the best way to sneak into the country. While there in 1919, she found Dr. Anna Karlin, a Jewish Russian who had become an American citizen before returning to Europe to help with the Red Army. Anna agreed to serve as Marguerite's interpreter for the journey.

While in Moscow, the women were arrested twice, largely because Marguerite flaunted the country's bureaucratic expectations and restrictions. She broke into exhibitions, attended meetings she shouldn't have and waltzed through Russia with little regard for the strict provisions she was supposed to follow.

When the Russians showed her a communication she had secretly sent to MID, Marguerite knew her cover had been blown. Apparently, they had been aware all along of her true identity. Under compulsion, she agreed to provide them information on other foreigners. Marguerite figured she could get away with giving the government "partial or misleading information for a while. Eventually I would be discovered, but perhaps not until I had accomplished my mission in Russia."

After roughly ten months in Russia's infamous Lubyanka prison following her second arrest, she was freed, largely because of conditions the U.S. government had set in providing famine relief to Russia, including releasing all American prisoners. Although she returned to the *Sun*, again Marguerite found that she could no longer simply work as an average reporter. Soon, she took up a new occupation: explorer.

By 1922, only ten months after her release, Marguerite had started a tour of eastern Asia, visiting Japan, Korea and China. This time, she went not as a spy but as a reporter for *Cosmopolitan* and *International Magazine*. Nonetheless, MID kept close watch on her movements and advised its other agents abroad to be careful when interacting with her. MID had stopped trusting its agent.

While in Japan, Marguerite was warmly received by the highest levels of society; the premier Baron Kato even treated her to tea at his house, a rare privilege. From her interactions, Marguerite correctly concluded that Japan was likely to attempt conquering other Asian countries, a prediction over a decade ahead of its time.

Although Japanese officials welcomed her, they were, like the American authorities, also keeping tabs on her. With her publications and speaking engagements, Marguerite had become a public figure—and one known to have strong opinions. At a time when America was increasing its isolationist policies, she was not just advocating a more international approach;

she was living it with her travels. Marguerite had become increasingly controversial—something neither MID nor Japan appreciated.

Next, she traveled to Sakhalin, an island between Japan and Russia, before continuing on into Japanese-controlled Siberia and then Korea. Eventually, she reached China. She met with aboriginal peoples like the Giliaks of Sakhalin, interviewed the Manchurian warlord Chang Tso-lin and stayed in an abandoned Chinese temple.

While she journeyed, an article appeared in the Japanese press, picked up from the British, alleging that Marguerite was a Russian spy. The accusations embarrassed the officials who had only recently welcomed her, and they were quick to declare her innocence.

Marguerite, on the other hand, decided she wanted to return home through Russia itself. She ventured on a car ride through the Gobi Desert, all the while hoping that Lenin had softened his policies and would allow her to return to his country. However, within twenty-four hours of arriving in Russia's borders, she was arrested yet again.

Marguerite was taken back to Moscow via the Trans-Siberian Railroad. She was transferred between prisons, eventually returning to Lubyanka and even staying in one of her old cells. After several weeks in prison, Russian authorities made Marguerite a surprising offer: stay in Russia and spy for it. It would even bring her son over.

What would be Marguerite's response? She had certainly become a pest to American officials and was entranced with Russia. Her previous time in Russia had made her more appreciative of the Bolshevik Revolution. Her political views were evolving and no longer aligned with American policies.

Would she defect?

"I shall never work again for any government, my own or yours," she replied. "I would rather die in prison." Marguerite would not be any country's puppet. She existed to dig into untold stories and share them with the world. That was her mission. She would no longer be a spy.

After three months imprisoned, Marguerite was released in February 1923. She remained a complex woman, continuing to write about her love for a country that had regularly arrested her. Nonetheless, while her answer had been dramatic—and ambivalent—she returned to America.

However, she would never remain stateside for long. She became involved with the documentary *Grass*, which took her to Iran and featured the summer migration of the Bakhtiari people, who crossed over mountains without shoes. Marguerite served as co-producer and even as a de facto doctor to the people during their forty-six-day trek. After the film was finished, she

stopped in Palestine (modern-day Israel) before eventually returning to the United States again.

Back home, Marguerite continued to publish, both as a reporter and in book form. In 1925, she formed the Society of Women Geographers with three friends. The new organization would support and recognize the accomplishments of female explorers, much needed when the majority of existing clubs excluded women from membership. The society continues to thrive today.

Marguerite went on to remarry—an action that surprised her perhaps as much as anyone else. She had never expected to marry again, since it was difficult to balance traveling and public life with the societal expectations of being a wife. Nonetheless, after meeting the English actor Arthur Blake, she fell in love, and they were married in 1926.

Not that marriage slowed her down—much. The couple spent two years in Morocco and traveled regularly between France and the United States until the outbreak of World War II. Even with her complex patriotism, Marguerite made regular radio broadcasts for the USO throughout the war.

Even after Arthur passed away in 1947, Marguerite, then seventy, continued traveling across the world. She also worked on philanthropic projects and spent more time with her family, which soon included grandchildren. She passed away in 1967 in Baltimore at the age of eighty-nine.

BETTY LUSSIER: WORLD WAR II'S QUEEN OF THE SKIES
1921–Present, Eastern Shore

"In our youth we did not see the absurdity of two girls from a Maryland farm going to war against the formidable fighting force that was Germany," writes Betty Lussier in her memoir, *Intrepid Woman*. As young women from Rock Hall on the Eastern Shore, Betty and her sister Nita dreamed of taking on the Nazis. Such patriotic fervor was in their blood, as their father, Emile John Lussier, had been a fighting ace in World War I. Both women wished to follow in his footsteps and become fighter pilots themselves. Of course, if they had been born male, they would have undoubtedly easily succeeded.

While studying at the University of Maryland–College Park, Betty managed to secure a spot in the newly formed Civilian Pilot Training (CPT) program, a government mandate to develop a new crop of civilian pilots.

Betty Lussier. *Library of Congress.*

"In the event that the United States would be drawn into a war," writes Betty, "these CPT pilots could be called upon to patrol the coastlines, be on the lookout, and report any invading Nazi U-boats they spotted." Betty was the rare woman accepted into the program, but they denied her sister Nita entrance for being too young.

Somehow Betty managed a full course load, the CPT requirements and working a number of part-time jobs to make ends meet. She worked a midnight shift at the Glenn Martin plant making bombers. Because American entry into the war took away so many men, companies could no longer exercise sexist practices. As a result, many Maryland women were soon at work at Glenn Martin and similar operations. Still, even though she was now working on planes, Betty didn't give up on her dream of flying them for the war effort.

Although raised in Maryland since she was four, Betty was born in Canada. As such, she could also qualify as a British citizen. In July 1942, she learned about a new British program that would cover the costs of people like her returning to England so that they could help fight the war. While Betty felt "guilty and unpatriotic," she nonetheless declared herself British and headed overseas. In England, she joined the Air Transport Auxiliary (ATA), becoming a ferry pilot. She taxied people and flew planes across the country as needed, earning her wings and becoming a third officer. The ATA provided much-needed support to the Royal Air Force (RAF).

In 1943, the authorities announced that ATA pilots would begin ferrying supplies across the English Channel to the European continent as well. This would help prepare the RAF for the coming invasion of France. Betty would have been thrilled, as she longed to participate in the combat zone. Except that the ATA decided that only male pilots could go. This shocked her, as up until that point, the ATA had treated its female pilots as it had the men.

Right: Maryland aviatrix and friends. *Photo by Marion E. Warren, Maryland State Archives.*

Below: A woman working on an airplane engine during World War II. *Library of Congress.*

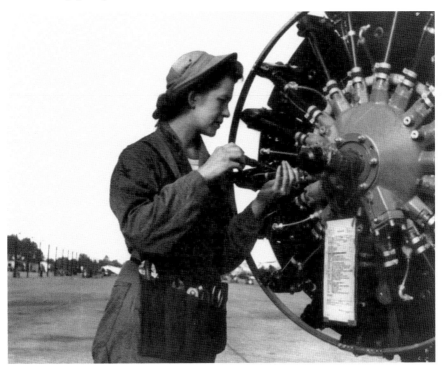

"They paid us the same as men and advanced and promoted us just as if we were real citizens. It was the first time I saw equality with men, and that really amazed me," said Betty in an interview with the *Palisadian-Post*. She went on to say, "I loved flying so much I would have stayed, but I really wanted to do what the men were doing."

Torn about what to do, Betty set up a meeting with one of her father's old squadron buddies, William Stephenson. He also happened to be a high-ranking British intelligence officer who served as the liaison to the Americans (and is often considered the real-life inspiration for James Bond). William told Betty about a new American initiative, the Office of Strategic Services (OSS), which would engage in espionage activities on the continent.

Betty decided to sign up, shifting from being a pilot to a spy. Because of her dual passports, she was able to join the special liaison unit (SLU), whose job was to distribute information to American units gleaned from intercepted messages by the British. The Brits had recently cracked Germany's infamous Enigma Machine, which encrypted its top-secret communications. The British called the intelligence gathered from these deciphered messages "Ultra," while the Americans deemed it "Ice." British officials closely guarded this secret, so while they wanted to share information with their American allies, they only trusted the decoded material to those with British citizenship, like Betty. Being an SLU made her highly sought after among American military authorities.

She became involved with the elite X-2 operations of the OSS, which was a counter-espionage branch. Using Ultra/Ice intel, Betty and X-2 were able to uncover many Axis agents. "We really trained ourselves how to catch spies; we invented it as we went along," explained Betty. She started by working in Algiers but was soon transferred to Sicily and Italy ahead of the Allied French Invasion. Before long, they were working in southern France, where Betty and Nita were reunited, as Nita had also achieved SLU status.

Betty's team uprooted several Nazi spies, including a traitorous French lieutenant. They found him squirreled away in a farmhouse with his family, transmitting messages back to Germany. Using his family as bait, the X-2 team convinced the lieutenant to serve as a double agent for the Allies. He complied.

In another incident, they discovered a man who served as a paymaster to a host of spies. He had been interrogated harshly by the French but refused to give up any names. One of Betty's colleagues, a Spaniard named Ricardo Sicre, found the man's weak spot: he dreamed of being a Charlie Chaplin–like star in Hollywood. After they convinced the paymaster that they could help that happen, he gave them everything. Even better, the man had foolishly

written down the contact information for the thirty-five spies he paid—as opposed to simply memorizing their details—and was able to give it to the X-2 team. They were able to track down all of them and even convinced a handful to become double agents. Most of the remaining, including the paymaster, did not likely survive the war, as most spies were generally shot.

After the war ended, Betty and Ricardo married and moved to Madrid, Spain. Unlike her parents, who had four girls, the couple welcomed four boys into their lives. Betty's love for adventure remained strong, leading the family to take on farming in Morocco. She wrote about her experiences, including helping with social development in the country, in her memoir, *Amid My Alien Corn*.

The family continued to move around across the world. Eventually, Betty and Ricardo split, although they remained close. While Betty ultimately retired to California, she continues to return to family in Rock Hall, Maryland, for regular reunions.

Virginia Hall Goillot: World War II's Limping Lady Spy
1906–1982, Baltimore

When Virginia Hall lost her lower left leg in a hunting accident in late 1933, she likely suspected that her dreams of becoming a Foreign Service agent were dashed. Perhaps she should have been content with conducting clerical work in such exotic locations as Warsaw and Venice, but Virginia wasn't one to give up on her ambitions—leg or no leg.

Besides, even without the injury, very few women were accepted into the Foreign Service. Most officials didn't believe that ladies belonged there, let alone one with a prosthetic leg nicknamed "Cuthbert."

But Virginia Hall was unlike most people. Instead of letting her injury or sexism hold her back, she pursued new opportunities. Before the end of World War II, she would become one of the most important spies that most Americans have never heard of.

Born in 1906 in Baltimore, Virginia came from a well-to-do-family that stressed education and encouraged her to pursue her dreams, no matter how wild. This encouragement inspired her to become a Foreign Service officer. She had already been working abroad in Europe when she accidentally shot her foot during an excursion in Smyrna, Turkey. Virginia had been hopping

over a fence to chase after her prey when the gun was caught and triggered. Amputation of her lower leg saved her life.

While she continued to work for American embassies in Italy and Estonia, she was unable to pass the exams to enter the Foreign Service. Realizing she would never be able to progress past clerical work, Virginia resigned in May 1939. Her paperwork allowed her to remain in Europe for up to a year.

Virginia decided to spend a few months in France. She was there when Germany invaded Poland. On September 3, France and England declared war against Germany. Suddenly, she was in the middle of a war zone. Virginia hated the German Nazis. She had heard stories of how the Nazis treated Jews and seen the rise of anti-Semitism across the continent.

Unable to sit by and do nothing, Virginia volunteered as an ambulance driver with the Services Sanitaires de l'Armée, a department akin to the Red Cross. She went out to the front line to provide medical treatment to French soldiers. In a sad twist of fate, Virginia even ended up tending to the brother of one of her driver friends. Unfortunately, he died.

After France surrendered to Germany, she left for England, again becoming a clerk for the American embassy. Although the Germans attacked London several times, Virginia refused to return to Maryland.

Her strength of character, knowledge of French and American papers caught the attention of the British Special Operations Executive—a secret department similar to the CIA. Virginia was offered a chance at her dream of being an agent, except for the British, not the Americans. Wanting to fight the Nazis however she could, she gladly accepted.

After rigorous training, Virginia returned to France in 1941. Unlike other British agents, Virginia could operate freely in the country, since America had yet to enter the war. Virginia worked behind the scenes to help the French resistance grow, handling the logistics of parachute drops bringing in new agents and supplies and securing safe houses.

Meanwhile, she reported for the *New York Post*. Having a cover story as a journalist came in handy more than once, as it provided a reason for her to be in wartime France and gave her more leeway to talk with people.

After America entered the war, however, Virginia became just as much of an outlaw as the other British agents. The Germans soon began searching for the "limping lady," who kept interfering with their plans. They plastered posters of Virginia. Her cover was blown, and she needed to escape.

With few choices, Virginia trudged over the Pyrenees Mountains to enter Spain, a neutral country. The journey was perilous, given the high mountainsides, deep snow banks and potential of being caught. Although

her stump blistered and bled, she refused to reveal to her guide or traveling companions that she was an amputee. She didn't want them to worry that she would slow them down.

Unfortunately, after reaching Spain, she was caught by officials. Her passport had not been stamped with the proper marks, and they realized she had snuck into the country illegally. She spent most of December in jail, where she befriended another prisoner. When the other woman was released, she went to the American embassy on Virginia's behalf, and after a few weeks, Virginia was freed.

She tried continuing her efforts in Spain but didn't feel like she was helping her friends back in France. Many of her allies there had been caught and were now imprisoned. Virginia couldn't stand waiting around, doing very little. Instead, she returned to England.

Now part of the war, the Americans had also opened an office in London: the Office of Strategic Services (OSS). This was the same office Betty Lussier worked for. The OSS asked Virginia to return to France. She jumped at the opportunity. Disguised as an old woman, she snuck across the English Channel in a motorboat before heading deep into the French countryside.

Virginia found more people looking to resist the Nazis. She soon had upward of 1,500 men reporting to her. They blew up train tracks, arranged supply drops and spied on Nazi activities. She risked her life making regular wireless transmissions back to London, which the Nazis could potentially trace.

After D-Day launched, Allied soldiers joined Virginia's efforts. One of those soldiers was Lieutenant Paul Goillot, who caught her attention—albeit in a nonmilitary way. As the Allies advanced, Virginia and Paul were sent on missions deeper into Europe. In the spring of 1945, just before they started a new mission, Virginia and Paul learned that it had been canceled—because the Germans had surrendered.

Following the war, France, England and America showered Virginia with medals. She accepted them privately or in absentia because she wanted to remain undercover. She worked for the American OSS and then its descendant, the CIA.

In 1950, she married Paul. They retired to a farm in Barnesville, Maryland, in 1966. Virginia passed away in 1982 at the age of seventy-six.

Chapter 4
FIGHTING FOR FREEDOM

In the decades leading up to the Civil War, Maryland's women didn't wait for men to abolish slavery. Although the Victorian era was a time of severely restricted gender roles and robust racism, these women defied the odds, escaped difficult situations and inspired others to fight the tyranny of slavery and prejudice. Many people may know about Harriet Tubman, perhaps the most famous Marylander in history. However, they may not know much about her beyond her efforts with the Underground Railroad to free other enslaved people. Additionally, she was only one of a number of African American women with Maryland connections to dedicate her life to eradicating such deep social ills. Mary and Emily Edmonson and Frances Ellen Watkins Harper were two more of these valiant women who worked tirelessly for equal rights for all Americans.

During the Civil War, it is estimated that 179,000 black men fought for the Union army—approximately 10 percent of the entire corps! Another famous Marylander, Frederick Douglass said, "Once let the black man get upon his person the brass letter, U.S., let him get an eagle on his button, and a musket on his shoulder and bullets in his pocket, there is no power on earth that can deny that he has earned the right to citizenship." The efforts of these soldiers and of women like Edmonson, Tubman and Harper to fight for equal rights would lead, over time, to incredible social changes across America: emancipation and women's suffrage. Although the fight is not over, their work has brought our society much closer.

The Edmonson Sisters: Escape on the *Pearl*

1830s–1895, Montgomery County

In 1848, Emily Edmonson was only thirteen years old when she first tried escaping slavery. Born in Montgomery County, Emily and her fifteen-year-old sister, Mary, came from a large family with more than ten living siblings. Some of their family, including their father, Paul Edmonson, had been able to achieve freedom, but not Emily or Mary, who had inherited their mother Amelia's enslaved status. The girls were hired out as domestic slaves to a Washington, D.C. family.

On the evening of April 15, 1848, Samuel, the girls' elder brother, threw dirt at their bedroom window. This was the night they had planned for—a chance to reach freedom. The Edmonson siblings slipped down to the D.C. waterfront and onto a ship called the *Pearl*. Waiting inside were not only more of their brothers but dozens of other enslaved people as well—nearly eighty in total.

While several abolitionists planned the logistics of the *Pearl* plot, the attempt to bring so many people to freedom would never have happened if not for the brave individuals who put their lives in danger to enact it. While Emily and Mary had better lives than many slaves did, they were nonetheless willing to risk significant consequences if the plan failed. At best, they would return to their previous lives, but they knew their family could just as easily be split apart and sold elsewhere. But no matter the possible penalties, the potential for freedom was more important. If everyone could achieve liberty in one audacious move, the sisters believed that the plan was worth trying.

The *Pearl* headed down the Potomac River to southern Maryland. From there, the ship would turn north up the Chesapeake Bay and to freedom after reaching New Jersey.

The disappearance of so many slaves caught the attention of the authorities, who soon discovered that the refugees had taken off via the river. While the *Pearl* had a head start, the ship was delayed—first by a lack of wind and then by rough weather. However, it had almost made the turn into the Chesapeake Bay when officials caught up and forced it back.

Back in D.C., an angry mob had organized. Someone shouted at Emily, asking if she regretted her decision to run away. Emily held her ground, yelling back that she would gladly do it again.

Arrested, the siblings spent time in slave pens in D.C.; Alexandria, Virginia; and Baltimore. Although the transatlantic slave trade had been

outlawed in 1808, domestic slave trading persisted. The young women knew that they would likely be sold south and might never see their families again. They could even be split up from not only their brothers who had risked the journey with them but also from each other.

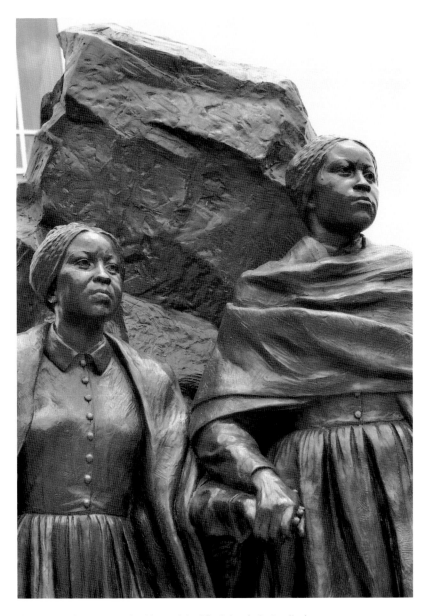

Edmonson sisters statue in Alexandria, Virginia. *Author's collection.*

Their family attempted to raise funds to free their relatives but only gathered enough money to purchase the freedom of one person. They selected Richard, one of the older sons, as his wife and children were ill. Unfortunately, the money didn't arrive until after the siblings had been shipped to New Orleans on a vessel called the *Union*. Richard remained on board, eventually learning that he was a free man.

The journey took over two long weeks. The trip could have been shortened by going through the Florida Keys, but the *Union* captain couldn't come to an agreement with the driver of a guiding pilot ship. While the two men argued over the fare, the Edmonsons and others had been forced into a tight, hot hiding place. Air ran out quickly, and the siblings nearly fainted. At the last moment, the trapdoor was released, and everyone survived.

In New Orleans, the sisters were marketed as "fancy girls," intended to be slave owners' concubines. They were dressed in pretty clothes and paraded across the ship's wrought-iron balcony, as if they were mannequins in a window display.

Surprisingly, the siblings did enjoy some good news. While in New Orleans, they were reunited with Hamilton, an elder brother who had been sold down South before Emily was born. Amazingly, he was now a free man and owned a business making barrels. His story gave the girls hope.

Soon, yellow fever gripped the city. The epidemic was savage, sickening thousands. In the previous year, around three thousand had died. Wanting to protect his investment, the slave dealer sent the girls back up to Baltimore with Richard, the one who had been freed before they left. The slave dealer planned for the sisters to return after the wave of illness passed.

While the siblings' lives were in limbo, their free family members continued working tirelessly to raise the funds to save them. With help from the Anti-Slavery Society and famed abolitionist Reverend Henry Ward Beecher (brother of the famous novelist Harriet Beecher Stowe) in New York, they eventually collected enough money to purchase the sisters' freedom.

After being set free on November 4, 1848, Emily and Mary began school and started speaking out against slavery on a cross-country lecture circuit. They attended Oberlin College, where Mary passed away from tuberculosis at the age of twenty. Emily went on to teach, marry and have children. Over her life, all but one of her brothers was rescued from the clutches of slavery.

HARRIET TUBMAN: MARYLAND'S MOSES

ca. 1822–1913, Dorchester County

Almost everyone has heard of Harriet Tubman, the runaway slave who braved numerous attempts to free others ensnarled in slavery's grasp. Her triumphs have reached near-mythic scale in American history and for good reason. However, they might not recognize her original name: Araminta "Minty" Harriet Ross.

Born around 1822 in Dorchester County on the Eastern Shore, Minty was one of nine children of Ben Ross and Harriet "Rit" Green. The entire family was enslaved, and when Minty was a young girl, several of her siblings were sold away.

Her childhood continued to be difficult, as she suffered through cruel beatings and whippings from either her owner or from the people to whom she was hired out for domestic work. The worst injury she sustained happened when she was only about twelve years old. On her way to the store, she encountered another slave, who had been caught trying to run away. His master demanded that Minty help tie the fugitive up, but she refused.

Angry, the man threw a two-pound weight at the runaway but missed. Instead, it hit Minty's head, causing significant damage. Minty received practically no medical treatment except to be laid out on a floor for a couple of days. Although she had not healed, she was quickly sent back into the fields to work. The injury left lasting ramifications, including narcolepsy and visions, which she saw as divine in nature.

However, she never let these effects keep her from achieving her goals. If anything, the wound awakened a deep spirituality within her, leading her to believe that she could communicate with the heavenly realm. This fervent religious belief would provide her with the fearlessness and steadfastness she would need to achieve her own awesome feats.

Around 1844, Minty married John Tubman, a free man. About this time and perhaps because of the wedding, she changed her name to Harriet, the same as her mother's.

In 1849, Harriet's master, Edward Brodess, suddenly died. Soon after, his widow, Eliza, sought to sell several of their slaves to pay back Edward's substantial debts. Various sales were announced in local newspapers, although most were canceled due to an ongoing legal debate over who actually owned Harriet's family.

Harriet even managed to hire a lawyer to research her mother's status. This action is truly remarkable for a number of reasons, not the least of

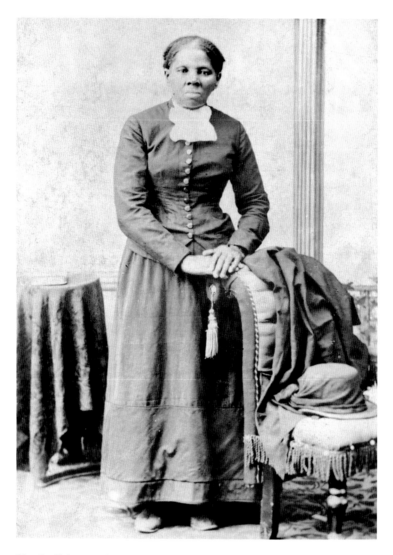

Harriet Tubman. *Library of Congress.*

which was Harriet's slave status, but also because she was able to use the money she collected from hiring herself out and because she was illiterate. When the lawyer discovered that her mother should have been freed some time earlier, Harriet was furious. Unfortunately, she had little recourse because black people had no legal standing against white people. However, her action may have been the spark that started the legal proceedings that stalled the sale of her relatives.

Nonetheless, with everything in limbo, Harriet decided to risk running away. With her brothers Henry and Ben, Harriet attempted leaving in the fall of 1849. Eliza Brodess posted an announcement in the local papers, offering a reward for their return. Unfortunately, the first escape attempt failed, and the family returned.

Soon after, Harriet tried again, but this time, she went alone. She couldn't tell anyone of her plans—not her husband or her parents. The risk of being found out, even by accident, was too great. Although she couldn't read, she did know the North Star and relied on that, along with assistance from others, to head toward Philadelphia and freedom. She worked around Philadelphia and Cape May, New Jersey, saving her meager compensation and making connections with the abolitionist community.

What makes Harriet's story amazing isn't just that she successfully ran away, although that would be enough on its own given the dangers she faced, but that she returned time and again. The first time she returned was in December 1850, after hearing that her niece Kessiah was about to be sold. She headed to Baltimore and stayed with her brother-in-law Tom Tubman, where she orchestrated an elaborate escape plan for Kessiah.

The auction for Kessiah and her two small children went forward, but when it was time to give her over to the new owner, they had disappeared, having been spirited away to a friend within a few minutes' walk of the courthouse. They were then taken across the Chesapeake Bay to Baltimore, where Harriet greeted them and led them up to Philadelphia.

Although Harriet didn't actually travel back to Dorchester County on the Eastern Shore for this successful rescue, she would for many more, often coming back to the small town that she had called home. Estimates vary about how many people Harriet successfully rescued, but many historians, including Kate Clifford Larson in *Harriet Tubman: Portrait of an American Hero, Bound for the Promised Land*, think she saved around seventy people on about thirteen or more trips during the course of eleven years. Another roughly fifty people left slavery with the help of her advice and instructions. Sarah Bradford, one of Harriet's original biographers, put the number closer to three hundred people "spirited away" from roughly nineteen trips. Kate Clifford Larson mentions that Harriet herself "claimed to have made only eight or nine trips and rescued approximately fifty people by the summer of 1859." Whatever the exact number, Harriet's extraordinary work and success lifted so many from the hands of bondage. She truly became a modern "Moses," and many people called her such, even during her lifetime.

Harriet eventually returned for her husband, John, only to find that he was not interested in leaving the Eastern Shore and had married another woman. While they would never be together again, Harriet kept her husband's last name for the rest of her life.

She was, however, able to bring out the majority of her family members, including her parents and most of her siblings, along with a host of their spouses and children. Unfortunately, she couldn't save everyone, but it wasn't for a lack of trying. She attempted many times to rescue her sister Rachel and Rachel's children, Ben and Angerine. Unfortunately, Rachel died in captivity, and her children could be saved only with a bribe of thirty dollars—something that Harriet didn't have. However, since she was there, Harriet was able to save another group of people, including a small baby. Her niece's and nephew's fates remain unknown.

In 1858, she worked with abolitionist John Brown to recruit people for his planned raid on Harpers Ferry. He deemed her General Tubman, and the two had great respect for each other. She was held in high esteem by fellow Marylander Frederick Douglass, who had also escaped slavery from the Eastern Shore.

After the start of the Civil War, Harriet served in several different capacities for the Union army, including as scout and spy, nurse and launderer. She excelled at each of these roles. She was particularly talented at helping men overcome diseases, such as dysentery, using medicines she derived from local plants. Amazingly, she never contracted illness while working to nurse the soldiers. She spent most of her time at Port Royal, South Carolina.

In 1863, she led an assault along the Combahee River along with Colonel James Montgomery. Following her lead, three steamboats maneuvered mine-infested waters until they successfully reached the opposite side. Once there, troops set the plantations ablaze and pillaged for supplies. The steamboats blew their whistles, and newly liberated people appeared. They clung to the boats and sailed for freedom, even as their former masters yelled and shot at them. This successful raid was the first time a woman had led such an attack in American military history.

While the government paid her only a little for her services, Harriet was soon accused of receiving preferential treatment by other soldiers. To allay people's concerns, she gave up the salary and made her money instead by baking food and selling it to the soldiers and others in the camps. She would also try sending funds back to her family, who were now settled in Auburn, New York. William Seward, now secretary of state, had given Harriet a piece

of land there for $1,200. Although far from perfect, the home became a fixture for her growing family.

After the war ended, Harriet eventually returned to New York. Attempting to travel by train, the conductor ordered her into the smoking car. She showed him proof of her government work, but he didn't care—seeing only the color of her skin. Harriet refused to move, and it took multiple men to physically haul her off the train. She was never one to back down from fighting for what she believed in!

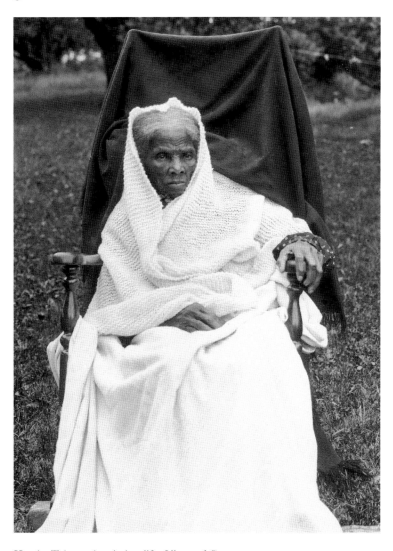

Harriet Tubman late in her life. *Library of Congress.*

Back in New York, Harriet was reunited with her family. She eventually remarried a much younger man, and they adopted a baby named Gertie in 1874. Harriet had already been serving as the de facto mother for another young girl, Margaret. Their relationship is unclear, as Harriet claimed to have taken the girl from free parents, although it's uncertain why she would do that. Some historians suspect that Harriet was actually Margaret's mother but had hid the truth. The reality remains a mystery.

After seeing emancipation become law, Harriet shifted her focus to other humanitarian causes, including women's suffrage, the African Methodist Episcopal Zion Church and caring for the elderly—of which age group Harriet was joining. She turned her home into a place for black senior citizens, donating the land to her church. However, she was dismayed to discover that the church was requiring a $100 entry fee. Harriet had spent her whole life giving away what little she acquired, and she wanted to see that philosophy extended to others who were even more in need.

Harriet lived to be ninety-one years old, passing away in 1913. Today, Harriet remains one of America's most famous citizens. She was well known in her time, the subject of biographies, including, most notably, one by Sarah Bradford. Although a somewhat amateurish attempt, Sarah's work sold considerably, and she gave the proceeds to Harriet. More recently, in December 2014, Congress passed legislation paving the way for multiple national parks to be named in her honor in Maryland.

Frances Ellen Watkins Harper: The Novel Abolitionist

1825–1911, Baltimore

Frances Ellen Watkins was born free in Baltimore in 1825. Raised and educated by her uncle, William Watkins, he helped mold both her literary talents and her progressive political leanings. He fought against both slavery and forced colonization attempts, arguing, "We are not begging [slave owners] to send us to Liberia. If we are begging them to do anything, it is to let us alone." His model influenced Frances, who would work tirelessly over the course of her life for the abolitionist cause, as well as civil rights for all.

In 1839, she began working for Mr. Armstrong, a local book merchant, who shared his library with Frances Ellen. By the age of twenty-one, she had published *Forest Leaves*, a collection of both poetry and prose. Unfortunately,

no copies of this work still exist, but she had also successfully submitted works to various newspapers. In the biography *Discarded Legacy*, author Melba Joyce Boyd recalls how her work "was of such surprising quality that the originality was doubted."

As an adult, she moved frequently—teaching at a university, publishing both fiction and essays and speaking on the abolitionist circuit. She gave her first lecture in 1854 in New Bedford, Connecticut. Thanks to the support of the State Anti-Slavery Society of Maine, Frances toured the Northeast and into Canada.

She also prolifically published her poetry, including one of her most famous pieces, "Bury Me in a Free Land." The poem begins with a strong image of freedom, identity and death:

> *Make me a grave where'er you will,*
> *In a lowly plain, or a lofty hill;*
> *Make it among earth's humblest grave,*
> *But not in a land where men are slaves.*

It ends by continuing that powerful theme:

> *I ask no monument, proud and high,*
> *To arrest the gaze of the passers-by;*
> *All that my yearning spirit craves,*
> *Is bury me not in a land of slaves.*

She sent the poem to Aaron A. Stevens, one of the participants in John Brown's failed, but fatal, raid on Harpers Ferry in protest of slavery. Like John Brown, Aaron was found guilty of treason and sentenced to death. He wrote back to Frances, thanking her for the "beautiful verses" and letting her know that John Brown had made a copy of the poem before his execution.

In 1860, Frances married Fenton Harper. They had a daughter together, in addition to the three children he had from a previous marriage. The family settled on a farm in Ohio, and Frances retired from her public work.

After Fenton passed away in 1864, Frances returned to the public arena. Now that slavery was outlawed, she worked on fighting for civil rights for both people of color and women. She toured the South and pushed for Reconstruction, especially for the Fifteenth Amendment, which allowed men of all colors to vote.

However, this put her at odds with prominent white suffragists, who were concerned that the bill did not cover women. Frances agreed that women should also be treated as equals under the law, but she believed that a more comprehensive bill would not pass. She would rather see African American men receive the right to vote than see the vote not be extended to anyone. She felt that she could wait a little longer for women's turn.

Furthermore, Frances noted that many white suffragists wanted equality primarily for white women. While some strove for civil rights for all, racism was still pervasive. In 1866, Frances spoke before the Woman's Rights Convention in New York, saying, in part:

> *I do not believe that giving the woman the ballot is immediately going to cure all the ills of life... You white women speak here of rights. I speak of wrongs. I, as a colored woman, have had in this country an education which has made me feel as if I were in the situation of Ishmael, my hand against every man, and every man's hand against me. Let me go to-morrow morning and take my seat in one of your street cars—I do not know that they will do it in New York, but they will in Philadelphia—and the conductor will put up his hand and stop the car rather than let me ride.*

In response to Frances's speech, renowned suffragist Susan B. Anthony proposed a resolution calling for "Universal Suffrage" and suggested that the organization rename itself the "American Equal Rights Association." Within a few weeks, the newly reformed group met in Boston with the purpose "to secure Equal Rights to all American citizens, especially the right of suffrage, irrespective of race, color or sex."

Frances also continued to publish, where she broke new boundaries. Having already become the first African American woman to publish a short story ("The Two Offers" in 1859), she went on to become the first to publish a novel (*Iola Leroy: or Shadow Uplifted* in 1893). Her novel spans decades, telling the story of a young woman, Iola Leroy, who was raised as a free person, only to discover that she was actually a slave. She unknowingly had passed as white until her uncle decided to sell her south. The story explores Iola's personal journey as the Civil War and then Reconstruction occur.

Frances spent the rest of her life fighting for social justice, extending it to not only civil and women's rights but also becoming involved with the temperance movement and pushing for education equality. She became a leader with several national organizations until her death in 1911.

Chapter 5
CHANGE AGENTS

The work of Maryland women like Frances Ellen Watkins Harper to fight for increased equality continued into the twentieth century. Although women had been unable to secure suffrage with the passage of the Fifteenth Amendment, they didn't stop speaking out—be it to the press, their legislators or anyone with working ears. Maryland women also continued the struggle to improve civil rights, regardless of skin color. Living conditions for African American people were harsh. While slavery may have ended, discrimination went on unabated. Although these were largely uphill climbs, these ladies were able to achieve impressive feats.

EDITH HOUGHTON HOOKER: MILITANT SUFFRAGIST
1879–1948, Baltimore

On a hot summer night in July 1910, Edith Houghton Hooker rose up from a large touring car. She intended to convince the growing crowd that women should be given the right to vote. Just before she spoke, a man heckled, "Oh, [women] would all vote the same as their husbands, so it would only be a case of more votes to count. The result would be just the same." Her colleague in arms, Reed Lewis of the Men's Suffrage League, took the shouter to task, disagreeing with his naïve sentiment.

Edith Houghton Hooker. *Author's collection.*

With her organization the Just Government League, Edith and her supporters had come to downtown Baltimore with a novel concept: taking their message to the masses by means. Although Edith stemmed from a well-to-do family, she didn't turn up her nose at driving through the city and hosting these "open-air" meetings. They distributed pamphlets with titles like *Persuasion or Responsibility*, *The Division of Labor* and *More Testimony from Colorado*.

Edith appealed to the mothers in the crowd, promising that if they succeeded in acquiring the right to vote, their efforts could lead to better nutrition for their families, such as cleaner milk and water. "Because we are the mothers and therefore, would take more interest in this matter than the men would," she explained, as quoted in the *Sun*.

"What would you do with the baby while you went to vote?" shouted another heckler.

Quick on her feet, Edith replied, "Well, we have to leave the baby every day while we attend market…Surely, if we can leave him every day in the year to attend to the buying of home necessities, we can leave him one day in the year to vote."

The heckler had no response.

Although born in Buffalo, New York, in 1879 and educated at Bryn Mawr College, Edith came to Maryland by way of graduate studies at Johns Hopkins University. She was one of the first women admitted to its medical school. While there, she met Donald Hooker, who became her husband. They settled down in Baltimore after a short stint in Berlin, and Edith worked as a social worker.

Edith became increasingly involved in improving the lives of women, which she tackled in a number of ways, including founding the Guild of St.

George for single mothers, participating in various suffrage organizations and publishing widely, including *The Laws of Sex.*

Initially, Edith took part in suffrage societies that focused on state-level advocacy efforts, such as Bessie Ellicott's Equal Suffrage League of Baltimore and Emma Maddox Funck's Maryland Suffrage Association. However, she became frustrated when the general assembly rejected their efforts. She founded her own organization, the Just Government League, which was influenced by the more direct and militant efforts of national leaders like Alice Paul, who pushed that all action should be focused on the larger goal of passing a new Constitutional amendment securing women's right to vote.

Inspired by this goal, Edith took her message to the streets of Baltimore, inaugurating both "open-air" meetings in the summer and parlor room sessions in the winter, teaching classes so that her supporters would be ready to debate detractors and editing the weekly journal *Maryland Suffrage News.* She used unorthodox tactics, including speaking on stage between acts during a performance of *The Gamblers.* And she did not focus her appeal only to "high society" people, such as when she hosted a lawn party for 50 low-wage female workers from the Henry Sonneborn & Sons factory. According to Mal Hee Son Wallace's profile of Edith in *Notable Maryland Women*, "During the year of 1913 alone, Edith Hooker organized 214 parlor-meetings with a total attendance of 19,410 as well as 86 open air meetings at which over 9,500 men and women were addressed. In addition, 114,000 Marylanders were given suffrage literature."

In late June 1912, Edith participated in a "triumphal march" for suffrage. The *Sun* covered the remarkable event. Tens of thousands crowded Mount Vernon Square in Baltimore to watch the parade, as "Joan of Arc…with her steel armor scintillating in the glare of the electric lights, waved her mailed hand from her seat on a snow-white charger." A band followed and then "the multifarious line of men, women, chariots, horses, banners and bands glided into a line a mile and a half long…It took 23 minutes to pass a given point." Even aforementioned "wild woman" Margaret Brent made a posthumous appearance through another impersonator.

Edith served as "generalissimo" of the events. Like "Joan of Arc," Edith also paraded on horseback, leading other women. "In regulation riding costume, the somberness of the riders was relieved only by the suffrage tri-color—purple, green and white—draped over their shoulders," remarked the *Sun.*

The parade was fun and humorous but always to the message of the fight for suffrage. The children's float included the banner, "Mother mends my

Suffragists parade. *Library of Congress.*

socks and shirts, Mother mends my coat, Maybe she could mend some laws, if she had a vote."

Of course, becoming such a public face included handling strong backlash. Just as in today's world where website commenters can hide behind fake names and false identities, so, too, did Edith have to contend with an anonymous editorialist who signed most of his letters "Most Highly Amused." In 1912, the letters to the editor from "Most Highly Amused" (or his likely subsequent moniker "Correspondent") began being published in the *Sun.* Over the following year, he would make arguments against women's suffrage and viciously attack Edith's arguments in particular, writing quips like, "Because there are five illiterate men to one illiterate woman we should swell the illiterate vote by adding that of illiterate women. They would diminish the proportion. Truly, if you have three bad children and one good one in a room, and admit two more good ones, truly you diminish the proportion of bad ones; but how about the effect on the good children?"

In response to his antics, a new commenter called "Daughter of Eve" began submitting pro-suffrage letters to the editor. After "Most Highly Amused" apparently decided that the two people were one and the same,

"Daughter of Eve" argued that she was not Edith. On June 4, 1912, she wrote, "It is sincerest flattery to be mistaken for our inimitable leader, but it places me in a false position, and my natural modesty forbids me to accept an honor which does not belong to me. As an evidence of my good faith, I would suggest that 'Highly Amused' and myself conduct our correspondence in this column over our own signatures."

It does not appear that either writer took up the suggestion.

By 1915, Edith's organization boasted 17,000 members. Her *Maryland Suffrage News* included not just local subscribers but also those in surrounding states and even some as far as the West Coast. Not surprisingly, Edith's work caught the attention of national suffragist leaders. In 1917, she became the editor of the National Woman's Party's *The Suffragist*. At the same time, Edith joined suffragists from twenty-six states in picketing the White House for close to a year. Many of her colleagues were part of the 218 suffragists arrested for demonstrating when America joined World War I.

However, this time also signaled a turning point for the right to vote. That same year, several states took measures giving their women suffrage. Perhaps the change derived from the efforts of women (and men) like Edith. Perhaps their message converged with public support for American involvement in the war so as to save democracy in the world. Whatever the case, finally, in 1919, Congress passed the Nineteenth Amendment, giving women suffrage.

But the battle wasn't over yet.

Suffragists lobby the House of Representatives. *Library of Congress.*

For the amendment to become national law, thirty-six states needed to ratify it. Edith wanted Maryland to be included. Nor was she alone. All of Maryland's suffragist leaders advocated for its passage. Even national leaders like Alice Paul came in to help buttress their efforts. But for all of their work, the amendment failed in the state. Fortunately, her colleagues across the country had better luck, and Tennessee became the thirty-sixth state to accept the amendment, making suffrage national law.

More than once while campaigning for suffrage, Edith was asked about running for office. Although she always hemmed in her responses, it would be interesting to imagine what her amazement would be today, since as of this publication, Baltimore is led by its second consecutive female mayor.

LILLIE CARROLL JACKSON AND JUANITA JACKSON MITCHELL: CIVIL RIGHTS CHAMPIONS
1889–1975 and 1913–1992, Baltimore

Lillie Carroll Jackson and her daughter Juanita were a veritable dynamic duo in the fight for equal rights for African Americans. Descended from both an African tribal chief and Declaration of Independence signer Charles Carroll, the women inherited a strong sense of leadership and vision.

Born in 1889 in Baltimore, Lillie grew up to teach school and sing soprano in the Sharp Street Baptist Church choir. Kieffer Jackson happened to be visiting the church during a national tour showing early religious films. He requested that she sing "The Holy City," which she obliged. By 1910, they were married. They had three children, including Juanita, who was born in 1913.

Because of segregation in Baltimore schools, Juanita could only attend Frederick Douglass High School. Fortunately, the school provided a strong academic foundation for her later successes. She was classmates with such notables as Cab Calloway, the celebrated musician, and Thurgood Marshall, the future Supreme Court justice.

As a young woman, she and her friends would don turbans and speak in French to shop in Baltimore's downtown department stores, challenging their segregation policies. The store employees sold them anything they wanted, thinking that the women were international visitors.

Because of discrimination, Juanita and her sister Virginia were unable to attend their preferred universities, the University of Maryland and the

Maryland Institute of Art, respectively. They had to go to Pennsylvania to continue their education. While pursuing multiple degrees at the University of Pennsylvania, Juanita began touring to discuss race relations. In 1931, she also developed the City Wide Young People's Forum in Baltimore with Virginia. The forum met on Friday nights, providing an environment for young men and women to discuss potential solutions to achieve racial equality and offering speakers from the leaders of the civil rights movement.

In 1933, the forum began taking action, organizing a "Buy Where You Can Work" boycott. Several stores in black neighborhoods would not hire African American employees. With her supporters, Juanita picketed at an A&P grocery store. When no black customers would cross the line, the manager quickly changed his policies. Their success spurred more boycotts not just in Baltimore but nationally as well.

Lillie encouraged her daughters' efforts and carved her own path of civil rights activism. In 1935, she became the head of the Baltimore chapter of the National Association for the Advancement of Colored People (NAACP). The organization, which had been dwindling in membership, flourished under her administration, gaining more than 17,600 members in just over ten years. She would lead the chapter for thirty-five years.

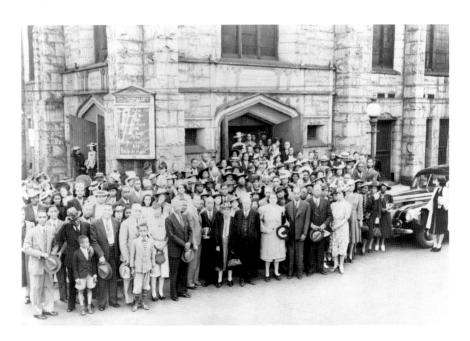

First Maryland State Conference of NAACP, Baltimore, Maryland. *Library of Congress.*

She enacted much of her advocacy efforts over the telephone. Governor Theodore McKeldin once apparently quipped, "I'd rather the devil got after me than Mrs. Jackson. Give her what she wants." Lillie also reached out to Juanita's former classmate Thurgood Marshall, who was now a lawyer for her chapter. In his biography on Marshall, author Juan Williams recalled how Thurgood would receive extended calls from Lillie. He'd lay the receiver on his desk as she pushed on, interjecting every now and then so that she would know he was still listening.

Meanwhile, daughter Juanita began working for the national headquarters of the NAACP in New York City. While there, she became engaged to Clarence Mitchell. Their wedding became a major event in Baltimore, featuring a who's who of civil rights leaders and NAACP standouts. Approximately 1,500 people attended the celebration. After marrying, the two settled in St. Paul for his work, and she raised their first child.

Soon, the family returned to Baltimore, and although she had more children, Juanita resumed her civil rights work, including voter drives, marches and other advocacy efforts. She decided to forge a new frontier, becoming the first African American woman to attend the University of Maryland Law School. She joined the editorial board of the *Maryland Law Review*. In 1950, she graduated and passed the bar, becoming the first African American woman to practice law in Maryland.

As a lawyer, Juanita provided counsel on several important and successful cases, including forcing the desegregation of Mergenthaler Printing School and Western High School in 1954, making Maryland the first southern

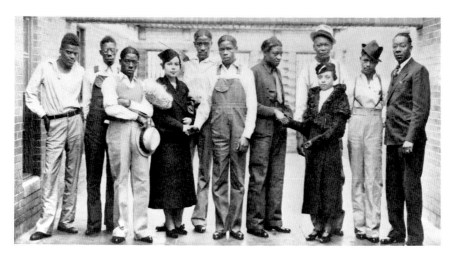

Juanita Jackson (fourth from left) and the Scottsboro Boys. *Library of Congress.*

state to desegregate after the influential *Brown v. Board of Education* decision; integrating Maryland beaches and parks in 1955, which went on to have positive national repercussions; forcing city agencies to end racist hiring practices in 1963; and stopping police from entering private homes without warrants in 1966.

Juanita's children continued their mother and grandmother's legacy of enacting social change. Two of her sons entered local politics: Clarence Mitchell III became a delegate and state senator, and Michael Bowen Mitchell joined the Baltimore City Council before becoming a state senator. Lillie's great-grandson Kieffer Jackson Mitchell also joined the council and serves as a state senator presently.

Gloria Richardson Dandridge: Crusader in Cambridge
1922–Present, Cambridge

In June 1963, the National Guard came to Cambridge, seeking to quell the difficulties that had flared between the town's segregated black and white wards. Shots rang out. A guardsman leveled a rifle toward a group of unarmed people when a woman stepped in his way. Local activist Gloria Richardson pushed at the gun, willing to endanger herself in the name of civil rights.

In Jeff Kisselhoff's *Generation on Fire*, Gloria described that moment, saying, "I had been inside a little shoeshine place talking to General [George M.] Gelston, the head of the National Guard unit in town when I heard this bang. We thought it was bullets, so we went crashing out of there. When I got out in front to see what was happening, this Guard charged me. I was furious, so I pushed his rifle away and cursed at him. I was thinking, 'What on earth do they think they are doing?'"

Although her efforts in fighting for equality were undeniably courageous, they stemmed from the basic values on which she was raised: standing up for her beliefs and serving her community. From a young age, Gloria's parents instilled in her the importance of these tenets, regardless of the discrimination they faced being African American.

Gloria hailed from the St. Clair family. Although the family was well respected in Cambridge, they could not escape the deeply entrenched racism of prewar Maryland. Even though they were firmly middle class, educated

and politically engaged, her family was still segregated to the town's second ward, along with the rest of Cambridge's black community, who were predominantly living well below the poverty line.

Gloria's middle-class background enabled her to pursue higher education, and she attended Howard University. Through her family and the university, she learned about the contributions of other black Americans, including local Eastern Shore standouts Frederick Douglass and Harriett Tubman. During this time, she also participated in her first activist experience, joining a successful sit-in at the dean's office to change the women's curfew.

After graduating, Gloria returned to Cambridge in 1944 and married Harry Richardson the following year. She worked in the pharmacy she had inherited from her father, John Edward Hayes. He had died because of discriminatory policies at the local hospital, where the doctors had refused to treat him due to his skin color. Although Gloria tried to settle down and focus on her growing family, she found she could not ignore such constantly unfair treatment.

In early 1962, Freedom Riders, a group of civil rights activists, came to Cambridge, seeking to change the town's prejudiced practices. "The protests started with a knock on my door," recalled Gloria. "It was these two fellows from SNCC [Student Nonviolent Coordinating Committee]." They were looking for young people to help with demonstrations, and Gloria's daughter Donna quickly volunteered. Gloria also became involved, largely inspired by the young people's actions and passions.

Before long, Gloria was heading the Cambridge Nonviolent Action Committee (CNAC). CNAC reflected the wide range of socioeconomic levels of African American society in Cambridge, ranging from those who were well off like Gloria to those who needed public assistance to survive. Gloria believed it was important for CNAC to be inclusive of people from all walks of life, not discriminating against someone who may lack a college education or had a drinking problem. Everyone was affected by segregation, and they would be a stronger force if they stood together.

CNAC started off by hosting voter drives. It surveyed its constituents' needs and issues. Based on this feedback, CNAC sought to change several city policies to improve life for the black community, such as integrating social services, especially in the areas of education, jobs and healthcare. In the spring of 1963, the group took its report to Mayor Calvin Mowbray and the city council, seeking immediate changes. However, the elected officials not only disagreed but also openly insulted the group. The mayor even called them "Freedom Raiders," mocking both CNAC and the Freedom Riders.

Undeterred, Gloria and CNAC arranged sit-ins for the next seven weeks. They held demonstrations throughout Cambridge, including at the city hall, courthouse and jail. Although she was arrested along with eighty other protesters, Gloria remained unfazed. They were all in it together.

In early May, the protesters were taken to court for "penny trials." Judge W. Laird Henry subjected Gloria to a patronizing lecture, saying that she was degrading her family's respected name. He then fined all the protesters a penny each and suspended their sentences. Instead of appeasing the situation, however, the judge's actions inflamed the protesters.

Gloria Richardson. *Library of Congress.*

CNAC supporters conducted more sit-ins, fully expecting to be arrested. Gloria and her mother, Mabel St. Clair Booth, were arrested on May 14, 1963, during a sit-in at the Dizzyland Restaurant. Gloria's daughter Donna was also arrested the same day at the Dorset Theater. Before the night was over, sixty-two demonstrators were arrested.

Perhaps realizing that CNAC would not back down, Judge Henry relented. He freed everyone arrested and started the Committee for Interracial Understanding (CIU). The CIU agreed with CNAC that schools needed to be integrated and encouraged equal employment, building a public housing project and appointing a black deputy sheriff. But while those recommendations sounded great on paper, in reality, the CIU did not wield any true authority. Nor did it have any African American members.

Realizing that things wouldn't improve, the boycotting and protesting continued. On May 25, a group of twelve students picketed the Board of

Education. They were arrested before being released to their parents. After being set free, the students were suspended from school. At the same time, Gloria joined a group boycotting the Colonial Store until its administration agreed to hire more black employees. However, the victory was a small one in a tidal wave of bigotry. Most local companies, agencies and white citizens refused to relent and change their employment practices.

The final straw for the protesters followed the arrest of two fifteen-year-old students: Dinez White and Dwight Cromwell. Because the teenagers had participated in the protests instead of attending school, they were sentenced to correctional facilities. Dinez had already been arrested earlier that spring for protesting outside a segregated bowling alley. The police had tried carting her away after she knelt in prayer. In response to Dinez's arrest, Gloria had said that the police "will have to pack the jail with us [protesters]. They won't hold her in there alone." She held true to her word.

Leaflets flooded the city's second ward, urging its predominantly black residents to "Please sleep in the courthouse and the jail, city hall and the regular places. Let them know you are not afraid and we shall overcome sooner than you think…They think they have you scared because they are sending us away, but we aren't afraid. We expect to be out in three months so please fight for freedom and let us know we are not going away in vain." Meanwhile, CNAC took to the streets with loudspeakers to encourage demonstrations. More than twenty protesters were arrested.

Meanwhile, Gloria and other representatives met with the CIU and members of a statewide commission on racial relations. Talks didn't get very far. Few white members of Cambridge's community were interested in voluntarily integrating. James Busick, superintendent of Dorchester schools, refused to accelerate desegregating the lower grade schools, nor would he consider opening up all the county's public schools to black children. With little signs of success likely to occur, the CIU announced it was disbanding.

In early June, violence erupted. Gloria's cousin Frederick M. St. Clair was quoted in the *Sun* as saying that about one hundred members of the CNAC were

joined by about 200 more Negroes after the committee demonstrated with a prayer vigil at City Hall. He said the Negroes were walking from City Hall to the second ward…when about "400 whites" began harassing the Negroes with firecrackers. He said he also heard gun shots. The only injuries, he said, were powder burns to Negroes…The whites began chasing the Negro demonstrators and that two white policemen, waving riot sticks, yelled to the whites that "they" could do anything they wanted to do to us after they got on Elm Street. After

running for about three fourths of a block, the younger St. Clair said, the Negroes turned. He said there was "somewhat of a standoff" then and that the two groups stood bickering for about half an hour to 45 minutes.

Crowds amassed. Fires broke out in the second ward's white-owned businesses. Three men were shot. Flying bricks injured others. Police found Molotov cocktails at a restaurant, grocery store and an auto body and fender shop. In the mêlée, Gloria was hit in the stomach with a riot stick by police but was, fortunately, not hurt.

On June 14, Governor J. Millard Tawes sent in five hundred Maryland national guardsmen to Cambridge to restore order and declare martial law. CNAC welcomed the guardsmen, since the state troopers on scene had "proven as intolerable and prejudiced as local police." Many businessmen from the white community, on the other hand, didn't view the arrival of the guardsmen in the same positive vein. Rather, they likened the guardsmen coming to an occupying army.

Gloria joined a few male representatives from CNAC in meeting with the governor and others interested in ending the protests happening in Cambridge. However, although she attended the meetings, she didn't have any faith in them. Unwilling to engage in petty social conventions, she refused to shake hands with the others in attendance and sat through the sessions silently. CNAC again argued for improved conditions in the areas of employment, education and housing. The state officials offered to integrate the schools, bring on a black civil servant into the employment office and develop a biracial commission to help improve racial conditions. In return, they wanted CNAC to agree to stop demonstrating for a year and to accept the current city council member representing the second ward.

Gloria rejected the compromise.

Her reasoning was clear: "We wish to make it unalterably clear that we will determine, and not the political structure of the city, who shall speak for the Negro community. The day has ended in America when any white persons can determine our leaders and spokesmen."

Furthermore, CNAC's representative refused to give up protesting. Gloria figured that the authorities weren't as interested in improving racial relations as they were in ending the negative press Cambridge had received nationally.

Unable to broker a deal, the United States Justice Department brought in a mediator. Gloria continued to respond with stony silence. Officials next tried offering a charter amendment to improve integration, but Gloria surmised that any amendment would likely fail when put to the voters.

In July, Governor Tawes removed the guardsmen from Cambridge. Not surprisingly, demonstrations and protests resumed. Fights again broke out. Segregated mobs clashed, and people and businesses were hurt. Even so, Gloria continued organizing protests. On July 12, a "freedom walk" of roughly 250 protestors headed to the courthouse, where they encountered roughly 700 white locals waiting for an arrested white man to be released. The protestors were pelted with eggs and rocks and, after nightfall descended, harder violence. Although no one was killed, 12 people were shot overnight.

Gloria and CNAC went back to the negotiating table with state and federal officials, including Attorney General Robert F. Kennedy. However, city officials didn't attend. They came up with a five-point "Treaty of Cambridge." It was better than the previous offers, but the treaty still included the charter amendment provision.

Not surprisingly, the charter amendment was challenged by a referendum vote. Gloria believed that a minority group's civil rights shouldn't be determined by a majority vote so she refused to actively support blacks' participation in the vote. If she pushed for voting in the referendum and the charter amendment was defeated, then what recourse would she have? Instead, she decided to stand by her belief that subjecting civil rights to a popular vote was wrong, making the outcome of the vote inconsequential. To Gloria, basic civil rights should be guaranteed—plain and simple.

Not everyone agreed with her. Maryland's NAACP chapter opposed a vote boycott. Even the Reverend Martin Luther King Jr. disagreed with Gloria. When the charter amendment was repealed by votes, he expressed his disappointment, telling her how important it would have been for the black citizenry of Cambridge to vote and reminding her of how disenfranchised they were in the South. Gloria disagreed. Because Cambridge's black citizens had long had the ability to vote, she didn't understand how a social condition elsewhere affected their local situation. While she wanted to see racial progress everywhere, she felt that the methods needed to achieve that end goal had to be tailored to the individual community's needs. While Martin Luther King Jr. was looking at the Cambridge situation from a national lens, Gloria viewed it from a local one.

In November 1963, Gloria traveled to Detroit to participate in workshops held by the Southern Christian Leadership Conference (SCLC). There, she befriended Malcom X. Like her, he felt that the national leadership had endorsed too slow and gradual of a process of improvement. Both wanted to see immediate and comprehensive changes. In the spring of 1964, she helped create ACT, which took a more radical approach than organizations like the

NAACP and SCLC. Malcom X served as a consultant. The organization lasted until 1967.

By the one-year anniversary of the "Treaty of Cambridge," little had been accomplished in the way of progress. Calm had been restored, but segregation remained rampant. White businessmen who had worked to repeal the amendment won several important council seats, including the mayoral seat.

Yet hope wasn't gone. Gloria's tireless efforts to improve racial conditions inspired a new wave of activists across the country. Many visited Cambridge and met with her. She helped young people prepare for demonstrations, including those setting out for Freedom Summer in Mississippi. Gloria had an impact on both black and white people who wanted to see positive change. She especially inspired young women, who saw a strong woman spearheading a movement and being treated seriously as a leader.

She also moved on with her life. Gloria stepped down from CNAC. She remarried and moved up to New York City. Part of the reason she left was to let the new generation of leadership grow. She also wasn't interested in turning CNAC into a cult of celebrity, nor did she seek a national career as a civil rights activist. She continued her struggle to improve the conditions of people's lives. She worked briefly with a number of different organizations before spending nearly a decade with the Harlem Youth Opportunities Unlimited (HarYou-Act). In his dissertation on her life, Joseph R. Fitzgerald, PhD, writes how she now continues her efforts "through her job in New York City's Department for the Aging, and as a union delegate where she serves as a leadership mentor to fellow union members." Her contributions haven't been forgotten. Several books about the story of civil rights include her, and Dr. Fitzgerald has the first scholarly biography coming out on her life, *The Struggle Is Eternal: Gloria Richardson and Black Liberation*.

BARBARA MIKULSKI: NOT POLITICS AS USUAL

1936–Present, Baltimore

One way or another, Maryland was going to have a female senator in Congress. In 1986, Republican Linda Chavez went up against Democrat Barbara Mikulski. The campaign was bitter. Linda called Barbara an "anti-man" feminist and made implications about her sexuality. Linda also enjoyed the full weight of the Republican Party backing her, including President

Ronald Reagan stumping on the trail for her. But if she had learned anything from reviewing Barbara Mikulski's career, Linda would have understood that she needed every trick in the book to take on her four-foot, eleven-inch opponent. Barbara was a pint-sized steamroller.

Several years earlier, in 1973, Barbara had bought a house. It wasn't anything fancy. Rather, the Fell's Point row house in downtown Baltimore was pretty run down. She told the *Sun* that she had "been looking for a house for several years. I wanted something I could afford to fix up."

The house also just happened to be right in the middle of a proposed highway—one that Barbara didn't want. "If Joe Axelrod [head of the interstate highway division in Baltimore City] drove his car down the [proposed] expressway, he'd run smack dab into my house," she quipped. Of course, Barbara assured the reporter that the house purchase wasn't "an act of protest." Rather, she explained how she had talked to locals, like area "tavern owners and the submarine sandwich guy," in finding the right place.

Barbara had been fighting the proposed expressway since the late 1960s, as it would bisect the historic neighborhood of Fell's Point and destroy the homes of both working-class black and white families and businesses. It didn't matter that she didn't have any big names supporting her cause. A trained social worker with a penchant for civic change, she organized her neighbors, who would be affected by the sixteen-lane highway. Under her leadership, they became the Southeast Council against the Road, or SCAR. The group of amateurs was up against a powerful city hall in support of the proposal.

They succeeded.

As she was mastering the ropes of community engagement, Barbara also began exploring the political tightrope as well. In the early 1970s, she sought to become councilwoman of the First District. As with the highway fight, Barbara was again a veritable David against a much more organized and larger Goliath—Baltimore's Democratic political machine. However, she was, as always, never one to back down from a fight. In 1971, against the odds, she won.

Isobel Morin's section on Barbara in *Women of Congress* sums up Barbara's experience on the city council: "During that period, [Barbara] showed her skills as a coalition builder. By patiently working to build a broad base of support, she succeeded in getting a bus fare reduction for the elderly, which had failed in three earlier tries. She also pushed successfully for the creation of a city commission to serve the needs of elderly Baltimoreans and for better treatment of rape victims."

Perhaps bolstered by her success, Barbara took on bigger dreams. In 1974, she campaigned for Senator Charles Mathias's seat. Several presses

called her attempt "foolhardy," and not surprisingly, she didn't win. But she managed to garner 43 percent of the vote—a tidy amount for a freshman councilmember from Baltimore in a statewide election. Her campaign manager, Ann Lewis, later told the *Washingtonian*, "She had two things in mind, I think. One was to introduce herself to voters who she knew would like her if they got to meet her. The second was to introduce herself to a political establishment that underestimated her."

While she hadn't yet made it to the Senate, in 1976, she did join Congress, becoming the new representative of the Third District, beating out seven other Democrats in the primary alone. There weren't many women in Congress at the time, nor was it easy for a junior member to get into the middle of the action. But Barbara never let custom stand in her path. "I didn't come to Congress to be on the beauty-shop committee," she told the *Washingtonian*. "I wanted to be right where the power was. But they told me: 'No woman has ever sat on [the Energy and Commerce] committee.'" As if that would stop this Marylander! She made friends and powerful advocates, which led to her being named to the committee.

In 1986, Barbara took on Linda Chavez. When Linda suggested that Barbara was against men, she responded, "Oh, yeah? That should come as a big surprise to my dad, my nephews, my uncles, and the guys down at Bethlehem Steel." Linda also questioned Barbara's sexuality, calling her a "San Francisco–style, George McGovern, liberal Democrat"—an implication that Barbara was a lesbian, something that would not have been well regarded at the time. Barbara, however, took the higher road and didn't retaliate in kind. No matter the nasty rhetoric or her high-placed friends, Linda fell to Barbara's smashing victory, as the representative took home a whopping 61 percent of the vote. As it reads in her official biography online, Barbara became "the first Democratic woman Senator elected in her own right," referring to the fact that she was not preceded by a male political relative.

In the Senate, Barbara continued to excel. She made friends in the right places, including pledging her support to Robert Bryd when he sought to become the majority leader. With the help from her advocates, she secured spots on two important committees: Health, Education, Labor and Pensions, as well as Appropriations. In fact, she was one of only two freshmen senators to be named to the Appropriations Committee, which is one of the most powerful, as it oversees federal spending. She went on to become the chair of the Appropriations Committee in 2012, a position she held until January 2015, when Democrats lost control of the Senate. She has also sat on additional committees, such as the Select Committee on Intelligence, and several subcommittees through her tenure.

Senator Barbara Mikulski. *Maryland State Archives.*

Although she's known to be a tough employer, Barbara is also considered a mentor to both those who survive working in her office as well as the many additional women who have come into Congress over the years. She wants to succeed so that she can meet her mission of supporting Marylanders, and she wants her fellow congresswomen to succeed as well. As she told the *Washingtonian*, "When I first came to the Senate, I felt like I had to prove a lot, partly because of the demands I always place on myself, and partly because I was the first Democratic woman elected in her own right. I felt if I succeeded it would be a victory for other women, but if I failed, I'd be failing all women."

Fair enough to say, Barbara has continued to succeed. In 2010, she became the longest-serving female senator and then, in 2012, the longest-serving female congressperson. In March 2015, the anointed "Dean of the Senate" announced her plans to retire at the end of her current term. At her press conference regarding her decision, she said that she wanted to focus on her constituents, not another in a long line of reelection campaigns. As Barbara summed up, "Do I spend my time raising money or do I spend my time raising hell?"

Chapter 6

POSTMASTERS AND PENCIL PUSHERS

Redefining Women's Work

There has long been a notion that women of yesteryear didn't work, or at least that they didn't work outside the home. Perhaps this has been true for women of Maryland's upper echelons, but for the majority of the state's female population, this is a lingering myth. Women have held a variety of positions in and across the state, not just the stereotypical "suitable" positions of teachers, governesses and seamstresses—which is not to degrade the important work that each of these jobs performs. As this chapter will show, women have been bar owners, hotel managers, journalists, police officers and much more.

In searching city directories of the nineteenth century, one will find that women often pioneered jobs that later became male-dominated industries, especially when "professionalized." We see this in ads for women running newspaper shops or as in the first entry here in which Mary Katherine Goddard became the state's first postmaster. Women in male-dominated settings also increased during major conflicts, such as the world wars.

Maryland women also organized and fought for better working conditions. According to the article "Human Creatures' Lives" in *Maryland History Magazine*, Baltimore women arranged strikes in factories no fewer than forty-five times between 1900 and 1917. However, these women were not monolithic, even when fighting for something better. The same article points out that while women in higher social classes sought reforms, such as child labor laws and restricting the workday, many of the women working in factories disagreed with these tenets,

A World War II poster. *Library of Congress.*

A Maryland woman and daughter sorting berries. *Photo by Marion E. Warren, Maryland State Archives.*

since it would force them to leave children at home and keep them from picking up extra hours.

And of course, women were often involved in less "respectable" professions. In *Wicked Baltimore*, I wrote about how government officials viewed prostitution, including the yearly "Ladies' Day," when madams paid an annual fine. Authorities often turned a blind eye to the many brothels so long as they paid up. In this book, we turn our attention instead to include some of the great research that has been conducted on Maryland women running bars and taverns.

MARY KATHERINE GODDARD: FREEDOM OF THE PRESS
1738–1816, Baltimore

Maryland women made inroads with a business that was not only run by men but was also controversial in the country's earliest days: the printing press. Printers enabled information to be shared widely—something that the English royals wanted to keep in check. Very few presses were run in the seventeenth century, especially outside New England. However, in the 1690s, William Nuthead opened his press in St. Mary's City after finding a cold welcome to the practice in Virginia. When he died in early 1695, his widow, Dinah, continued the work.

Within months, Dinah had moved to Annapolis, setting up her press there. She received a license to print blank forms for the government. Not only is this remarkable given her sex, but by all accounts, she appears to have been largely illiterate as well. Her forms were crude but effective. It's uncertain how long Dinah ran her press. She married a few more times and had additional children. At one point, she operated a ferry.

Dinah's trailblazing opened the door for other early female printers, including Anne Catherine Hoof Green in Annapolis and, most notably, Mary Katherine Goddard in Baltimore.

Starting in 1773, Anne's Annapolis-based *Maryland Gazette* began to compete with the newest newspaper game in the colony: *Maryland Journal & Baltimore Advertiser*. Although started by William Goddard, most of the *Journal*'s activities were conducted by his sister Mary Katherine.

Mary Katherine, born in 1738 in Connecticut, came to Baltimore in 1774, a year after William started the paper. The siblings had been educated

by their mother, Sarah Updike Goddard, in classical areas such as Latin, French and literature.

As William became invested in developing a colonial postal system with Benjamin Franklin, Mary took over the majority control of the newspaper. By 1775, the masthead read, "Baltimore: Published by M.K. Goddard."

Although it was Mary's name on the paper, it was often William getting into trouble for what the *Journal* published, including satirical pieces on British governance that confused and angered readers. Baltimore was a staunchly anti-British town, and residents weren't sure if the anonymous editorials actually supported England or were poking fun at royal rule. A local political group called the Whigs sent supporters to Mary, asking who wrote them. She refused to tell and instead foisted them off on her brother. This led to the Whigs running William out of Baltimore twice within a few months' time.

At the same time, however, Mary was the first colonial publisher to print the Declaration of Independence with all of the signatures. A copy of that publication is on display at the Maryland Hall of Records. She continued publishing the *Journal* throughout the Revolutionary War, being one of the first papers to report on what was happening with Lexington and Concord. She never missed putting out an issue during the war.

In the end, it wasn't war or mobs that ended Mary's publishing career. Rather, in 1784, Mary had some sort of falling out with William, which is not terribly surprising given his rather cantankerous nature. He replaced her name as publisher with his own. By the following year, he accused her of having "a certain hypocritical character." William returned to New England to marry, but his sister did not attend the wedding. While Mary had seen tremendous success with her newspaper, William had managed to fail at each of his operations and often made enemies with his unfiltered statements.

Instead, Mary remained in Baltimore. Even without the newspaper, she was busy running several other enterprises, having been appointed the city's postmaster in 1775, as well as running a dry goods and stationery store. When she was forced out of the postmaster position in 1789, over two hundred business leaders petitioned unsuccessfully on her behalf to Postmaster General Samuel Osgood. Today, the petition can be found in the National Archives, alongside other records from her tenure as postmaster. The reason she was kicked out? The authorities decided to professionalize the occupation, which translates to making it male only.

Mary died in Baltimore in 1816, whereupon she freed her slave Belinda Starling and bequeathed to Belinda all of her goods.

Eliza Anderson Godefroy: The "Ironside" of Ink Slingers
1780–1839, Baltimore

Only a few years before Mary's death, another Baltimore-based woman pushed new boundaries in publishing. At some point between 1804 and 1806, Eliza Anderson (née Crawford) became involved with the *Companion and Weekly Miscellany*. Curiously, during this same timeframe, Eliza accompanied her friend, a pregnant Betsy Patterson, on a journey to Europe to convince Napoleon Bonaparte that Betsy's marriage to his brother was legitimate. The venture proved disastrous, as the emperor refused to see Betsy and would not authorize her wedding. It appears that Eliza became the magazine's editor after she returned because, in October 1806, an editorial note disclosed the publication's editor as being a woman. The magazine didn't last much longer, but by the end of the year, Eliza had launched her own magazine, the *Observer*. She became the first American woman to found and edit a general-interest magazine. She was only twenty-six years old at the time.

Eliza edited the magazine under the nom de plume "Beatrice Ironside" and ran a regular editorial entitled "Beatrice Ironside's Budget." In the editorial, Eliza explained how she "happens to have been luckily constructed, so that she can turn an *ironside* to the 'proud man's contumely.'" In other words, the word "Ironside" derived from her self-described immunity to the public's vicious and insulting gossip. She continued writing, "Yet insolence and neglect she knows how to endure with the happiest indifference. She will therefore, always take the liberty of laughing at the affected, the ridiculous and the vain, both in the lords and ladies of the creation…not being very anxious about popularity."

Unfortunately, in reality, Eliza was far less indifferent. Author Natalie Wexler points out in a *Maryland Historical Magazine* article that "she devoted four pages of *The Observer* to answering a letter published in the *Federal Gazette and Baltimore Daily Advertiser* that had found fault with her characterization of Baltimore's cultural scene." Wexler points out that Eliza had once referred to Baltimore as a "Siberia of the arts."

While the back-and-forth volley over the arts is fascinating, soon, more and more attacks targeted Eliza's sex. Her character sustained additional public attacks after she translated the French novel *Clara d'Albe*, which depicts an adulterous relationship between a young woman married to a much older gentleman and his young ward. Some papers went as far as to indicate that the translation was actually Eliza recounting her own life, given

that her husband had abandoned her. Around the same time, in 1807, Eliza had begun a relationship with Maximilian Godefroy, a French architect who would go on to design Baltimore's battle monument and First Unitarian Church. Eliza divorced her first husband and married Maximilian in 1808.

Not long before their marriage, Eliza disbanded the *Observer*, pointing to the sexist attacks she had received and the magazine's unpaid subscriptions. Unfortunately, married life fared little better, and the couple fell into poverty and social anonymity. Her daughter from her first marriage died from yellow fever during an attempt for the family to find a better life in Europe. Although Maximilian eventually found a position in France, the couple continued to struggle until Eliza finally passed away in 1839 at the age of fifty-nine.

SARAH "SADIE" KNELLER MILLER: DAREDEVIL PHOTOJOURNALIST
1867–1920, Westminster/Baltimore

While at Western Maryland College (today McDaniel College) in the 1880s, the teenaged Sadie Kneller discovered a love for two very different subjects: journalism and baseball. She'd gone to school with the hopes of becoming an actress but became enamored with the relatively new sport of baseball while attending local games. Of course, it didn't hurt that she was falling for one of the players, Charles R. Miller. She never missed a game, even sometimes ditching class to catch one.

After graduating, Sadie began reporting for the *Democratic Advocate* in Westminster, which eventually led to a job with the *Baltimore Telegram*. Her new position combined her passions, as she began covering the recently created Baltimore Orioles. She also ended up marrying that talented player Charles.

Realizing the bias she'd be up against as not just a journalist but a female *sports* journalist, Sadie used "S.K.M." as her byline. This hid her identity well enough that when she was introduced to Andrew "Andy" Freeman, president of the New York Giants, he said, "Why, you're a lady!"

"I hope so," replied the quick-witted Sadie.

In addition to sports, Sadie reported on world events and took up photography. A photograph she took of three Spanish officers being kept in Annapolis during the Spanish-American War was published by *Leslie's Illustrated Weekly*, a major national newspaper. The submission led to a position with *Leslie's*.

While working for *Leslie's*, Sadie started with military assignments, including photographing top-secret facilities, and became the first woman to cover the national political conventions.

She traveled the globe, including hiking up the construction of the Panama Canal, covering earthquakes in Jamaica and San Francisco, visiting a leper colony on the Sandwich Islands and going solo through mining camps in Alaska near the Arctic Circle.

Her fearlessness led to her becoming a war correspondent, as she reported from the front lines of the Balkan War, as well as the start of World War I. Assignments took her to Mexico, Morocco and to secret military installations across America. While in Germany in 1914, she was captured and interrogated as a spy.

She frequently covered political and royal news and stayed on the forefront of women's rights. She took the last photograph of Susan B. Anthony before her passing. At the same time, however, Sadie signed her work for *Leslie's* as Mrs. Charles R. Miller. When asked why she didn't use her own name in a 1907 article for the *Baltimore American*, Sadie replied, "Because I am still prouder to show people that I have a husband of my own."

In 1909, Sadie recounted one of her more unusual experiences—driving through a Baltimore sewer: "Being a housekeeper in Baltimore I am naturally interested in any project which will better the sanitary condition, and when I learned that it was possible to travel in an automobile for six miles through this huge underground tube, I seized the opportunity and joyfully went into the great, dark sewer with a party of five gentlemen, who were actuated by this same interest."

After describing her driver and car, she went on to cover their odd adventure:

Here the mouth of the sewer loomed up like a huge monster ready to suck in the big automobile as it ran down the incline...We started underground. After a mile had been covered we began to run around sharp curves which showed the real beauty and remarkable construction work. The air was heavy, and in some sections a regular London fog shut out our view. Occasionally we passed a manhole which had been left open for ventilation, but the dampness had already settled over the big tube and there was something melodramatic about our surroundings, and we drove slowly for the next two miles, fascinated by the very weirdness of the place. Water from the recent rains had come in through the open manholes, and occasionally we were splashed with mud as the automobile went through the stream which

in many places covered the bottom of the sewer. Finally we reached a point just below Chase and Durham streets, where two smaller sewers empty into the main pipe. Here the automobile was to be turned and Mr. Gilbert [the owner and driver] *brought out his skids, when to our dismay it was found impossible to turn the big machine…There was no alternative, so we started on the return trip—to back out for more than six miles….Now, if you really want to be thrilled just back out of the Baltimore outfall sewer. I have been in gloomy underground places—in the very heart of coal mines, and far below the surface where men were bringing out gold—but I do not recall a like sensation to this backing out from the Baltimore sewer, for it seemed always that by the next turn of the wheels we would collide with the wall…We had scarcely gone a mile, when "bang!" and Mr. Gilbert stopped the machine…Alas the tire had exploded where there was plenty of water.*

Eventually, the group made it out safely. The underground expedition reminded Sadie of her childhood fantasy of digging a hole through her family garden. She tried a few times to carve out the passage using a pudding spoon beneath the honeysuckle bush, but the gardener "objected to the uprooting of his favorite climber."

Sadie passed away of a stroke in 1920. While she rarely enjoyed prestige during her lifetime, her work was rediscovered by Professor Keith Richwine and placed on display at McDaniel College, which housed a shrine to its remarkable alumna.

Ocean City's "Petticoat Regime"

Ocean City's first female entrepreneur was likely Zipporah "Zippy" Lewis, an abandoned wife, who foraged the beach for odds and ends, Spanish coins and whatever else the tide brought in. In the 1870s, she traversed the shoreline dressed all in black and pushing a small oxcart to carry her found goods.

At the time, Ocean City was little more than a quaint seaside village with few residents. However, starting in the 1890s, a handful of women transformed the sleepy fishing town into a desirable resort for a burgeoning middle class. Many women may have begun by simply letting rooms in their own houses or creating small boardinghouses, a fairly socially acceptable enterprise. One woman, Kendall "Jo" C. Hastings, started with selling the

The Hamilton Hotel, Ocean City, Maryland. *Author's collection.*

milk from her backyard cow at five cents a quart. Soon her house became a boardinghouse as well, which eventually grew into a hotel empire. Over her lifetime, Jo would run six different buildings and grow her business into one of the largest in the city.

By 1926, one advertising booklet (found at the Ocean City Lifesaving Station Museum) reveals that out of thirty-two hotels listed, thirty were woman owned and operated. One of the earliest entrepreneurs was Ella Phillips Dennis, who arrived in Ocean City around 1890. In a 1948 article with the *Baltimore Sun*, Ella, then eighty-six years old, was still operating her hotel, the aptly named Dennis Hotel on Baltimore Street. She had come to the area for her health, where she gained a remarkable—and needed—forty pounds. After such success, she and her husband decided to stay. He opened a general store—the first on the boardwalk—but Ella decided to dream bigger and build a hotel. The hotel was such a success that she continued with it until just three years before her death at the age of ninety. She passed away, but where? In the Dennis Hotel, of course!

Another early hotel operator was Rosalie Tilghman Shreve, a descendant of Maryland's early and distinguished Tilghman family. Like Ella, Rosalie found her way in 1890 to Ocean City, where she started a small boardinghouse business. By 1894, the business had expanded, and Rosalie opened the Plimhimmon Hotel. The hotel could house up to ninety people in its forty-eight luxurious and modern rooms. The rooms even had such novel inventions as electricity and indoor plumbing! Not surprisingly, Rosalie's business succeeded. Unfortunately, the building,

Historical marker, Ocean City, Maryland. *Author's collection.*

which stood on the boardwalk between First and Second Streets, was destroyed by a fire in 1962.

Nor were the women running only the hotel business. Rather, the ladies of Ocean City operated everything from rental agencies to a gas station to a bus service. Mrs. Robert L. Cropper ended up handling her husband's bus company when he became too involved with his plumbing and hardware work.

"On the average day," recounted the same *Sun* article, "Mrs. Cropper puts in twelve hours of work checking gas and oil, clocking drivers in and out, selling advertising space, and soliciting property owners along the north beach for patronage."

Elizabeth Showell helped convince her father of Ocean City's need for regularly scheduled mail. She then went on to run a number of additional businesses: a theater, bathhouse, bowling alley and property rental company.

While these enterprises represented significant progress for women, they were largely only for white women. Most of the beaches along Ocean City were segregated. In response, Lorraine Henry opened

"Henry's Beach" in 1952, which catered especially to African American families. Located in Somerset County's Dames Quarter, Henry's Beach was the first resort of its kind in Maryland and operated until 1982. A Maryland Historical Trust plaque still stands at the site, recalling how "families enjoyed a pleasant atmosphere including ballgames, bathing, fishing, crabbing, and home-style cooking, as well as the premier black entertainers and musicians of the period."

VIOLET HILL WHYTE: LADY LAW
1898–1980, Baltimore

In 1937, Violet Hill Whyte suited up as Baltimore's first African American officer—male or female. Granted, she wasn't given a uniform, a badge or even a gun, but that didn't stop her. Violet began her first day in mid-December 1937 at 7:30 a.m. More than one hundred people crowded the Northwestern District police office to attend a celebration in support of her. After giving a polite bow in appreciation and tidying up her office space, she set out to locate Lillian Burton, who was suspected of biting a man during a fight. Violet found her successfully and brought her in.

Captain Nicholas Gatch, who served as Violet's commanding officer, explained to the *Afro-American* newspaper that her duties would be "to assist in securing statements from women and minors arrested for alleged violations of the law; aid in clearing up domestic troubles among couples, make arrests, and be detailed in other districts [outside the Northwestern District] whenever needed."

Later on, she recalled how her supervisor set her out that day, saying to her, "There's no program here, no curriculum, so stretch your wings, young lady." She told the *Sun* in 1963 that she replied, "Yes sir, I said. And I did just that, and it's difficult since then to draw them in again."

Soon, Violet was involved with a bigger case: tracking down a potential murderer. Twenty-three-year-old Violet Key was accused of killing Charles Sales. Again, the rookie policewoman found her suspect. The young woman would be sentenced to six years in the penitentiary for the crime.

Although she primarily worked with juvenile and parental issues, Violet didn't shy away from other crimes like murder and drugs. "I've never had any fear of the underworld," she told the *Sun* in 1955. "And none of the work can

prove too hard for me." She shared how she went undercover as a "dope" user, walking the streets in a "simulated narcotic stupor" until approached by a dealer. She paid for more drugs using marked bills. When she returned to buy more, another dealer, suspicious of her, "shoved an automatic in my face, nice and cold. I stumbled back over him and in a feigned narcotic mumble pleaded for his cigarette. I knew he believed me when he shoved his dirty wet, [cigarette] butt in my mouth and allowed me to leave with my purchases." Using the intelligence she collected, federal agents soon raided the house and broke up the drug ring.

Another time, she faced a six-foot, four-inch supposed religious "prophet" who was suspected of housing minor boys and giving them alcohol. "No woman," he said, "has ever set foot in the prophet's temple." He blocked the doorway to his home holding his arms out wide. Although a small figure herself, alone and rarely armed, Violet faced him undeterred. She simply walked into his house under his outstretched arm. "Prophet," she said, "there's [sic] always has to be a first time." Her work led to his conviction.

During her career, Violet was always particularly interested in improving domestic relations and especially in helping the younger generation succeed. In 1954, she was quoted by the *Afro-American* as warning young people that they couldn't "sip cocktails, smoke incessantly, dance all night and indulge in promiscuous sex relations and still make it in the world of today." Instead, she recommended that they work on "getting all the schooling you can, exposing yourself to wholesome experiences and staying in good health." That being said, she assured the youth that she wasn't suggesting they become "Puritans!" "Have a good time…[but] plan your good times."

While she acknowledged that the work she faced was hard and that she needed to keep her emotions in check, Violet remained perennially optimistic, even about some of the hardest domestic situations. Finding a young mother attempting to raise nine children alone, she told the *Sun*, "We've got to make nine good citizens of those kids." Similarly, she didn't give up hope on an eleven-year-old mother she encountered. "Maybe we can make a worthwhile person of that child." She recognized that "a child who commits a delinquent act is not necessarily a delinquent child."

Violet pushed for a six-point child's bill of rights, including "the right of every child to be well born; to spiritual training; to an education; to proper custodial care and supervision from birth to maturity; to protection by child-labor laws; to civic and social education; [and] to narcotic and sex education."

She worked all hours of the night and day, starting between 5:30 and 6:30 a.m. and going for twelve hours. She handled upward of four hundred cases

a month. Even when attempting to take her first vacation in 1938, Violet was called back in to arrest a man suspected of burglary. Of all those cases, Violet explained to the *Sun* in 1963, only "50 to 60 are charged and tried. Much of our time is given to investigation. Only after everything else has failed do we bring anyone into court."

In a career spanning over thirty years, she never missed a day for being sick. Within two years of being hired, she was promoted for the first time, and over her career, she would receive several more promotions and commendations, including becoming a sergeant in 1955. At the time, she was only the third woman in the state to attain such a position. By the time Violet passed away in 1980 at the age of eighty-eight, she had reached the level of lieutenant.

Violet came from a successful family. Her parents were teacher and former lecturer for the Woman's Christian Temperance Union Margaret Pearl Hill and Reverend Daniel G. Hill of the Bethel AME Church on Druid Hill Avenue and Lanvale Street. Violet was one of ten children. Of the nine who survived to adulthood, they all graduated high school, and many went on to college. Most of Violet's siblings went on to be exceedingly successful in their careers, including serving as deans of universities and teaching at schools across the country. Violet graduated from Coppin State Teachers College (today Coppin State University) and began as a teacher and social worker. She married George S. Whyte, principal of School 127 in Baltimore, and raised children.

Her work paved the way for others. The city hired another African American policewoman in 1942, Carolyn Fletcher Robinson. Authorities, from commanding officers to governors to congressmen, also recognized and publicly appreciated the work she conducted. They nicknamed her "Lady Law." Judge Charles E. Moylan called her "a one-woman police force and a one-woman social worker combined. And the skill that she brings to the court in presenting a case is outstanding. She can do more work in an hour than an efficiency expert can do in three." Yet it was another tribute that Violet fondly remembered to the *Sun* in 1955. A second-grader came up to her and asked, "How can I become a good policewoman like you?"

EDITH "JACKIE" RONNE: UNEXPECTED ANTARCTIC EXPLORER
1919–2009, Baltimore

In 1947, Edith "Jackie" Ronne, a Baltimore native, prepared to wish her husband goodbye. Finn Ronne was getting ready to lead a research expedition to Antarctica aboard the *Port of Beaumont*. The expedition of twenty-one men planned to survey the icy continent's last remaining unexplored coastline. Finn convinced Jackie to join him as far south as Panama, knowing it would be a full year before they saw each other again.

However, when they reached Central America, Finn asked Jackie to join him in Antarctica. At first she assumed he was kidding but soon realized he was serious. Although she wasn't packed or prepared for such an adventure, she told him she would consider his request, knowing she'd have to decide by the time they reached Valparaiso, Chile—the last stop before leaving civilization behind.

She discussed the option with her friend Jennie Darlington, who was also on board with her new husband, Harry, one of the expedition's pilots. A few women had visited Antarctica before but none from the United States and certainly never for a full year. However, if Jennie would come, too, Jackie decided she would go.

Jennie agreed.

In South America, Jackie sent word back to her boss at the Department of State that she was resigning. He offered to hold her job for the year, but she felt that was unfair to the agency. She requested that he refill the position.

The *Port of Beaumont* reached Antarctica in March 1947, landing at Stonington Island in Marguerite Bay. Finn had constructed a base there during a previous expedition in 1939–41, known as the U.S. Antarctic Service Expedition. However, other nationalities had wrecked it in the interim. The group spent roughly two months making the space habitable—just in time for the winter months to hit.

Jackie documented their trip, writing articles for the North American Newspaper Alliance (NANA) and helping Finn with a book about the journey and its findings. She also helped out with the day-to-day operations, including cleaning, knitting and anything else she could offer.

She endured long days, snowed into a base that was rarely well heated. Confined in a difficult environment, tensions arose among the team, especially between Finn and Harry. In her diary, Jackie kept a record of their personality clashes, which ultimately culminated in Harry resigning. As a result, Jackie and Jennie's relationship also fell apart.

Right: Edith "Jackie" Ronne. *Courtesy of Karen Ronne Tupek.*

Below: Jackie and Finn Ronne with a puppy in Antarctica. *Courtesy of Karen Ronne Tupek.*

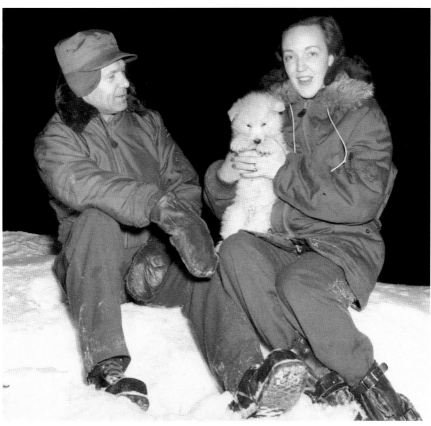

Jackie also chronicled unexpected treats, such as entertaining visitors from the nearby British base, enjoying the evening movie reel, meeting Adélie penguins, raising a Husky puppy named Kasko and taking classes from the other crew members in navigation and radio. She helped manage the seismograph and radio when others were away on missions and conducted her own hydroponic experiments, even managing to grow watercress in a subzero climate.

The crew radioed her articles back to the NANA, and they often made front-page news of the *New York Times* and other major newspapers. She shared the expedition's triumphs—including successfully photographing some of the last uncharted territory on earth—along with their several close calls, such as near-fatal falls by crew members into icy waters and crevasses, missing men who were finally rescued after several long days and a British plane crash, which everyone aboard amazingly survived.

One of the areas explored was named Edith Ronne Land in Jackie's honor. Later on, they would discover that the "land" was actually an ice shelf, and the place would eventually be renamed the Ronne Ice Shelf. The shelf is twice the size of the state of Texas. Combined with the

Seals in Antarctica. *Library of Congress.*

Filchner Ice Shelf to the east, the Ronne Ice Shelf is the second largest on the planet, after the Ross Ice Shelf.

Jackie and the crew left in February 1948 after a difficult but ultimately successful expedition. She recapped their accomplishments in her memoir, *Antarctica's First Lady*, writing, "Here the last unknown coastline in the world was delineated; it stretches from the Peninsula to the southernmost point in the Weddell Sea to Coats Land, a distance of about 450 miles. Scientists at the base and out in the field with dog teams conducted investigations in 11 branches of science." The expedition's pilots discovered new mountain ranges and glaciers, extensively photographing them. "Our three planes had flown a total of 356 hours in the air, covering 39,000 miles of Antarctic terrain, and they mapped over 450,000 square miles of previously uncharted territory," she wrote.

Jackie returned to Antarctica several times before her death in 2009. She ended her memoir remembering a return cruise fifty years after she initially left, writing:

> *Along with their parents, my grandchildren went with me in early 1998 as the fourth generation in Antarctica* [Finn's father had been an early explorer there]. *I have often tried to stay in the background as not to overshadow my remarkable husband, but when those around me toasted me as "Antarctica's First Lady" in many ways I wondered if, at my age, I shouldn't simply accept the applause and smile sweetly—so I did.*

TAVERN QUEENS

At the heart of many early Maryland communities was the tavern, also known as a public house or ordinary. These establishments were frequented by locals, gathering together for news, food and entertainment, as well as travelers stopping to refresh themselves while en route to their destinations. Today, we often hear how women didn't frequent taverns in the colonial period or that, if they did, they were supposedly confined to special sex-specific rooms with watered-down drinks. While this may have been true during the more regulated Victorian era, it was certainly not the case in the seventeenth and eighteenth centuries. Songs, diaries, newspaper entries and other primary sources demonstrate that women were a significant part of tavern culture in the colonies, as well as back in England.

For example, Charlotte Bristow Browne, a nurse at Fort Cumberland in Western Maryland, traveled with General Braddock's army during the French and Indian War. While in Virginia, she and her brother ate together at the Kings' Arms (still standing in Colonial Williamsburg) and lodged at a local inn together in the same room, which she noted in her diary. Similar entries can be found in the diaries of other women from across the colonies, showing that women staying at taverns were not unusual occurrences.

Sometimes women show up in records after being sued by tavern proprietors for unpaid tabs. Cases can be found in multiple counties across colonial Maryland.

Interestingly, some women even operated early taverns. In the early eighteenth century, approximately a third of public houses in Prince George's County were run by women. By 1750, in Annapolis, just under half had female proprietors.

There are different theories about why colonial women ran taverns. Some scholars believe doing so was born of out of economic need, especially if a woman was widowed. This suggests that running a public house was temporary, bringing in needed money until she could either remarry or find a more "suitable" occupation. However, records indicate that some women managed taverns for extended periods of time and even if they were independently wealthy. For example, Elizabeth Marriott owned the Ship's Tavern for at least fourteen years, even though her assets were worth around £538.10—a considerable sum for the time period. Her daughter continued running the operation after Elizabeth passed away in 1775, creating a new family tradition. Many other women also held business licenses to operate taverns for extended periods of time, such as Mehbitable Bateman, who had one for at least twenty years, and Deborah Wilkins, who maintained a public house for over twenty-two years.

And just like male owners had issues with their customers, so, too, did proprietresses face squabbles. In 1747, Isabella Arena brought a case against Elizabeth Kelly, a tavern owner, claiming that Elizabeth had beaten her. However, Elizabeth testified that the opposite was true, saying that Isabella had become intoxicated and then belligerent against her. According to the trial's transcript, Elizabeth said that "Isabella at the time in which the trespass and assault aforesaid is supposed to be done was drunk with drinking strong liquors." The court sided with Elizabeth.

In 1785, a curious story arises wherein Margaret "Peggy" Adams appeared in the public record, running a tavern in Bladensburg. By the time of the Revolutionary War, few women continued to operate bars.

Even more unusual was the fact that Peggy was African American. In his 1790 diary, Thomas Lee Shippen mentioned how he "breakfasted next morning at Bladensbgh with an old black woman who keeps the best house in town and calls herself Mrs. Margaret Adams." She was also listed as being black in the 1810 census. Yet her tavern was frequented by distinguished people, such as President George Washington and painter Charles Wilson Peale, who recorded her recipe for pickled sturgeon in his diary in 1789.

George Washington. *Library of Congress.*

In 1785, Peggy had inherited the tavern, along with 120 acres of land in Bladensburg, a plot in D.C. and several slaves, from Francis Hartfield, an English merchant. Their exact relationship is unknown, but it's interesting to note that Francis gave the land to Peggy instead of his sons.

While women owning taverns fell out of favor during the regimented Victorian era, the twentieth century brought a return to this tradition. For example, in 1919, Emma Quander Hawkins and her husband, Jeremiah, purchased a bar in North Brentwood, a community notable for being the first incorporated African American area in Prince George's County. By midcentury, Emma had sold the place to Marie "Sis" Walls, and the bar soon became known as Sis' Tavern. Prominent musical acts such as Duke Ellington and Pearl Bailey performed late night at Sis', generally after playing at Howard Theater in Washington, D.C. Sis' operated until around 1970. The building continues to stand and is being considered for renovation.

In Ocean City during the 1940s, Elizabeth Henry Hall ran a restaurant cum cocktail lounge with a fairly unique feature: boat-side service. A 1948 *Baltimore Sun* article recounted, "With its front on the ocean road and the back on a custom-made lagoon on the bay, Mr. and Mrs. Hall's 'drift-in and drive-in' establishment is well located to cater to both highway and bay traffic."

Pearl Bailey. *Library of Congress.*

Perhaps the most audacious bar/nightclub owner was Fannie Belle Fleming, better known by her stage name "Blaze Starr." In 1950, Blaze made her Maryland debut dancing striptease and burlesque at the Two O'Clock Club on Baltimore's infamous Block—an area downtown known for its strip clubs, bars and tattoo parlors. Blaze not only grew to become the Two O'Clock Club's headliner but also went on to purchase the building, which still stands and operates today.

Chapter 7
DANGEROUS DAMES

Some "wild" women who were once deemed unsavory by a leery public have now been recast as trailblazers for their work in defying social convention. Not all, though. Others continue to catch and hold our attention because they remain controversial today. Each of the following women faced trial for a crime she may or may not have committed. Unfortunately, however, their stories are generally told through the lens of others, especially in sensational newspaper articles hemmed by male reporters. As is often the case with historic women, we lack "their side" of the story. Perhaps there is more than the public record reveals, or perhaps they were truly capable of heinous crimes. Only they would know for certain, and they've taken those truths to the grave.

MARTHA "PATTY" CANNON: NOTORIOUS SLAVE DEALER
ca. 1760–1829, Eastern Shore

One of the most infamous slave dealers in not just the state but also the country was Martha "Patty" Cannon. She lived on the border between Maryland and Delaware along the Eastern Shore in the early nineteenth century. Patty was rumored to have been the head of one of the largest kidnapping gangs. The *Maryland Gazette* described her as "a strapping

Slave market in Washington, D.C. *Library of Congress.*

wench—a woman of great strength and ferocity. She could and often did knock down a stout man, tie him, put him in a cart and carry him over to [Joe] Johnson's." Joe Johnson was her son-in-law, the husband of her daughter Mary. For Patty, kidnapping was a family business.

While primary sources confirm Patty Cannon's existence, it's harder to tease out truth from fiction regarding how much she was involved in abducting free black people and selling them down south and out west. That the Cannon gang took people is well documented, especially by contemporary abolitionist groups, but what is less certain is whether Patty was running the operation (and also managing a tavern with captives chained upstairs), or if she was simply an abettor to the foul work done by her husband, Jesse, and her son-in-law Joe.

Much of the folklore stems from the *Narrative of Lucretia P. Cannon*, a fictionalized account of her life published in 1841, several years after her death. As Carole C. Marks writes in *Moses and the Monster and Miss Anne*, "There is little question that Patty Cannon married into a gang that kidnapped and murdered people. Beyond that is much speculation and little real evidence of what she did."

What is known for certain was that, along with family members, Patty was twice charged with considerable offenses against black people. In 1821, she and five family members were charged with abducting Thomas Spence, a free black man. Only Joe Johnson was found guilty and punished with nothing more than thirty-nine lashes. The others, including Patty, were set free.

Patty Cannon's name became synonymous with kidnapping, highlighting the very real threat that African Americans in Maryland regularly encountered. Even legally free black men and women could easily be stolen from their families and sold to slave owners elsewhere. Slaves were often worth double or more the price in the South than they were in Maryland, especially as the cotton market took off.

Not only was there the temptation of significant profit, but the laws of the time worked in favor of slave traders as well. Patty undoubtedly took advantage of the Fugitive Act of 1793, which allowed slave owners to seek out their runaway human "property." All that her gang needed to do was snatch a person, claim he or she was a "suspected fugitive" and have someone else authenticate the claim. African American people had little recourse since they were not allowed to testify against white people, no matter the seriousness of the crime.

In 1829, Patty faced a more difficult set of accusations after human remains were found on her land. Marks writes about the discovery: "A local farmer, plowing fields that adjoined her property, came upon a chest filled with human bones. The chest was identified as belonging to Cannon and the bones believed to be that of a Southern slave trader who had come into the area ten years before and disappeared. A search was

made for other bodies. Three more were dug up, including that of a child with a fractured skull."

However, Patty died while awaiting trial. Rumors abounded that she committed suicide, taking poison. Because she passed away, she was never able to give her side of the story, which would have either proved her monstrous ways or provided a different perspective on her life. Either way, she certainly wasn't winning any humanitarian awards.

NANCY HUFFORD: CUMBERLAND KILLER...MAYBE

ca. 1850s, Cumberland

In 1851, Nancy (Woodin) Hufford, a widow, was indicted for the murder of her Cumberland neighbor Rebecca (Broadwater) Engle. Nancy had been responsible for nursing Rebecca during the final days of her "confinement," or pregnancy. Not long after the birth, however, Rebecca unexpectedly died. Was it because of poor medical treatment or a difficult labor, or was it because Nancy had poisoned her?

The trial received significant press coverage in the local newspapers, including daily reporting from the *Sun*, which summarized each witness's accounts of Rebecca's death. The prosecution theorized that Nancy had poisoned Rebecca with arsenic. When examining Rebecca's husband, Samuel, during the trial, he revealed that Nancy had regularly made it known her feelings for him and that she wanted to marry him. While Nancy was never brought to the stand, another witness claimed that the opposite was true and that Samuel had been in love with Nancy. She had apparently rejected his overtures. His daughter from his first marriage confirmed that Nancy had "never asked me to effect a match with father." Unfortunately, it's impossible to know who was telling the truth.

One by one, the neighborhood gossips were questioned. Mrs. Knepper claimed that Nancy had freely shared her dislike of Rebecca. Savilla Long (one of Samuel Engle's daughters, now married to Perry Long) chastised Nancy for not taking care of her when she was in confinement, essentially wondering why Rebecca had received this special treatment. According to Savilla, Nancy had replied, cryptically, that Rebecca "was not as fixed as she is now, and that the devil was not in her as big then as it is now, or she would have come if the devil stood under the door."

Then there was the parade of scientists that trotted up to the stand. It's important to note that forensic toxicology was in its infancy. The Marsh Test, the first scientific method of detecting arsenic, had only been developed in 1836. Although useful, the test was not infallible.

Rebecca's doctor, Dr. Patterson, had been surprised at his patient's sudden death. He claimed that her labor had been easy, although a bit "contracted." He saw her a few times over the following days and was shocked when he arrived a week later to find that she was horribly sick. He described her symptoms in graphic detail, how she "salivated tremendously, her gums almost detached from her teeth; they were very black; and her tongue very dry, so much so that the saliva from the mouth would not keep the tongue moist. She complained of a great burning from her mouth to her stomach… her skin was very hot, burning up." He offered castor oil, but she said she couldn't keep anything down. So, he gave her a "small dose of calomel mixed with rhubarb" in powder form to be taken twice a day.

The next day she had improved. He returned again the following day and gave her a dose of salts, but she later said that they would "not lay on her stomach" and caused her to vomit violently. Although Dr. Patterson had recommended the salts, apparently it had been Nancy who mixed them. Had she added arsenic to them? The local apothecary reported that she had recently purchased some arsenic along with other medical supplies for a personal ailment.

Rebecca remained in relatively the same condition, even improving by midweek. Dr. Patterson felt assured that she would get over whatever was wrong. Others in the house suspected scarlet fever, but he didn't agree. He thought maybe it was puerpual fever but then decided that wasn't likely either because she didn't have lower stomach pains.

Instead of improving, however, Rebecca soon died. The baby, a girl, survived. She was named Martha.

Rebecca's body was autopsied. Dr. Patterson already suspected foul play. With colleagues, they removed her stomach, noticing a strange garlicky smell. One of the other doctors believed that indicated arsenic was involved. They sent their findings to Professor William Aiken (sometimes Aikin) in Baltimore.

He didn't find any evidence of arsenic.

Dr. Samuel Smith testified that he didn't think Dr. Patterson's description indicated arsenic either. Rather, he suspected typhoid fever from the symptoms that Rebecca had come down with. Another doctor for the defense agreed with his assertion, even though it was noted that this was an unusual case.

Within twenty-four hours, the jury acquitted Nancy of the charges.

What really killed Rebecca is still up for consideration. Perhaps Nancy did, either because she wanted to be with Samuel or for some other unknown reason. Maybe Dr. Patterson wasn't as good of a doctor as he thought. It's possible she did contract some sort of illness while recovering from giving birth.

In early toxicology cases, both sides would likely pay for experts to help with their cases. There was no official association setting rules or ethical guidelines for medical experts to follow or even certifying them. Anyone associated with an organization could be considered an "expert." That doesn't mean that these officials were necessarily wrong or corrupt, but it does mean that the arguments for and against arsenic need to be taken with a substantial grain of salt.

Interestingly, William Aiken would become an important witness for the prosecution twenty years later during the trials of Ellen Wharton, the infamous "Baltimore Borgia." Ellen went to trial twice for poisoning two of her friends over the course of a single week—one she apparently owed money to and the other being her accountant. Only the accountant survived.

Ellen suffered through a far more protracted trial, lasting nearly two months. Similar to this one, the prosecution and defense brought out a battery of scientists for their sides. Although understanding forensic toxicology had progressed over the decades, there had not been significant leaps in the professionalization of the study. This time, instead of typhoid fever, the defense claimed that the death was caused by cerebral meningitis, a little-understood disease. The jury again acquitted Ellen.

However, when it came to the trial for the poisoning of the accountant, the jury could not make up its mind, and a mistrial was caused. Fortunately for Ellen, it was never recalled, and she lived out her days with her daughter in a quiet town in Pennsylvania.

Nancy also went on to live out her days quietly, marrying Holmes Oliver Wiley. Was she guilty of the charges? It is hard to say. But from a circumstantial point of view, it should be noted that Holmes was Nancy's fourth husband. The first three had all died suddenly and unexpectedly. Her third, Samuel Hufford, supposedly passed away after eating some pumpkin pie. Perhaps Nancy, like Ellen, just was unlucky several times. It's not unheard of. Or perhaps she was extremely lucky and got away with murder.

DANGEROUS DAMES

Hattie Stone: The Bel Air Borgia
ca. 1920s, Harford County

In 1929, fifteen-year-old George Stone died suddenly and unexpectedly, much as his eighteen-year-old brother, Edgar, had eight months earlier and his father, Edward, two years before. The only remaining Stone, his mother, Hattie, was left overwhelmed and fainted at her son's funeral. She told others that her boys had been subject to convulsions for years. She claimed that George suffered from a bad heart, which prevented him from "play[ing] baseball like other boys." Perhaps that's why she had taken out a life insurance policy on him of more than $600, a decent, albeit not ridiculous, sum for the time.

Havre de Grace officials had George's body autopsied. The results were damning. He was found to have died from strychnine poisoning. Soon they had the other men's corpses exhumed from Angel Hill Cemetery. They also considered but eventually left alone the grave of Hattie's mother-in-law. Mary "Emma" Johnston Stone had passed away four years previously. "If George or any of the others was poisoned," said Hattie to the *Sun*, "I don't know who did it, and I probably never will."

Hattie's sister-in-law May Baker claimed that Hattie had admitted to poisoning her son. Why? So that she could skip out of town with not only the money but also a younger man: thirty-one-year-old James "Jimmie" E. Aberts, a railroad brakeman who had been lodging with the Stones. Hattie was forty years old at the time. Jimmie was also no peach, accused of abandoning his wife and three children. When held as a person of interest in the case, he admitted to "intimacies" with Hattie but also claimed to be through with her. Except they continued to talk privately while both were at the jailhouse, and he even accepted meals from her.

Hattie's lawyer cross-examined May about her accusations, which created a nearly Hollywood-like scene of witty repartee as recounted in the *Sun*. Harold E. Coburn, the lawyer, attempted to discredit May as being a divorcée. She replied that she "was not sure she had ever been divorced, although she remarried him the second time, 'just to make sure.'" He again tried to impugn her character, asking if she loved her husband. She agreed.

"But you love other people, too," Mr. Coburn pressed.

"Yes," the witness replied. "I love others just as you do."

The subject was dropped.

Dr. Charles Foley, who had been George's physician, disputed Hattie's claim that her son was sickly. He also revealed that George had previously been treated for strychnine, surviving the previous incident.

Hattie took the stand. The prosecution pushed that she was the one who gave George medicine, including the final fatal dosage. While she disputed that she had given her son poison, she agreed that the boy had complained about the medicine being bitter. W. Worthington Hopkins, the prosecuting attorney, asked Hattie, "Wasn't the reason you wanted to get rid of George because he was reaching an age where he could see you were running around with me?"

Hattie punted: "Everything I did was perfectly all right with George."

They pushed the idea that she wanted to collect on not only George's life insurance policy but also a trust his father left for him of about $1,200. According to the lawyers, Hattie was going to head down to Florida with Jimmie and the money.

For all of the holes the prosecution punched in Hattie's character, there was one gaping one left in its case: no strychnine had been found. Prosecutors tried to get the judge to allow a veterinarian neighbor to speak about how some of his had gone missing, but since there was nothing actually tying his theft to her case, the judge dismissed the possibility.

Additionally, the exhumations of her family members earlier in the summer didn't particularly help. Her older son Edgar's remains revealed no traces of poison. Very small amounts of strychnine were discovered in her husband Edward, but apparently not enough to warrant a second indictment. Granted, the longer the bodies decomposed, the harder it would be to find concrete evidence, but nonetheless, it was a boon to Hattie's case.

The trial lasted only a few days, and the jury deliberated for all of fifty-five minutes. Unlike the more confused cases of Nancy Hufford or Ellen Wharton, the evidence for poisoning here was fairly clear, and no one attempted to suggest that George had died from anything else. The question was just whether or not Hattie had done it.

She was found guilty of second-degree murder.

She received the maximum sentence of eighteen years. Hattie was fortunate to escape the death penalty that may have likely accompanied a guilty of first-degree murder verdict. In an editorial, the *Sun* commented on the second-degree verdict as being "illogical" but narrowed in on why, writing, "It illustrates the hesitation of juries, as a rule, to convict women of first-degree murders…while there is no escape from the conclusion that the facts demanded a first-degree verdict, or acquittal, juries often refuse

to be bound by logic when a woman is the defendant. Instead they draw a compromise between their desire to do justice and their unwillingness to find for the death penalty in the absence of direct proof."

In all of these cases, the jury was entirely composed of men, who likely did not want to be the ones sending a woman to the grave. Not to mention that they were already aware that these women, guilty or innocent, were being skewered in the press and had their reputations destroyed. The court of public opinion would be far less lenient on these ladies than any judge or jury.

Several months after the trial ended, the offending poison was discovered in Hattie's house. Now occupied by Homer Daugherty, he discovered "hidden in the rafters a package containing between a third and a half a pound of strychnine." The *Sun* pointed out that this was enough to kill around five thousand people.

Hattie occasionally reappeared in the press. A notice shows up in 1939 when she sought parole. The request was denied. Whatever happened to her after her eventual release remains a shadowy mystery. She disappeared from public record. In 2011, the *Havre de Grace Patch* wrote an article asking the same question but with few answers. Rumors float that she married the son of a prison warden, worked at a restaurant possibly in Baltimore and then was later buried in the same cemetery as her family but in an unmarked grave. But that's all they are—rumors.

Chapter 8
DEFYING EXPECTATIONS
Ladies Beyond Categorization

Most women are neither pure heroines nor full-fledged criminals. And while this book is a testament to the Free State's intrepid ladies, it only provides brief glimpses into their fascinating and complex lives. To round out our exploration of Maryland's women, the following profiles are of those who defy simple classification. From a would-be royal to the "Queen of Filth," these women refused to be boxed into the roles that society set and instead charted their own paths, no matter the detractors. While one may or may not agree with their motivations, their choices took them on journeys they likely never anticipated when they started on each of their paths.

WALLIS SIMPSON: THE WOULD-BE QUEEN
1896–1986, Baltimore

Amazingly, Maryland is home to not one but two women who so very nearly became royals but instead found themselves running afoul of foreign sovereigns and facing difficulty in the court of public opinion. Their marriages made them scandalous, both in their times and still today. Some say their stories are tragic tales of losing oneself to love, while others argue that these women were nothing more than "gold diggers" and "social climbers." The truth? That remains with them.

In the early nineteenth century, Elizabeth "Betsy" Patterson of Baltimore married Jerome Bonaparte, the younger brother of Napoleon. However, the young couple hadn't received permission from Jerome's famous sibling, and he refused to acknowledge their nuptials. Jerome ended up abandoning his pregnant wife and marrying another woman, who hailed from a different royal family. Except for a chance encounter at an Italian gallery, Betsy and Jerome never met again. And although Betsy spent the rest of her life petitioning for the Bonapartes to recognize her son's legitimacy, they never acquiesced.

Slightly over a century later, another Baltimore woman caught the attention of another European noble. Like Betsy, Bessiewallis "Wallis"

Wallis Simpson. *Library of Congress.*

Warfield stemmed from a well-to-do family. While married to her second husband, Edward Simpson, in the 1930s, Wallis was living in London, England, and working her way up the social ranks. She soon befriended Thelma, Lady Furness, who was also the mistress of Edward, Prince of Wales. Through Thelma, Wallis was introduced to Edward, who stood next in line for succession to the British throne.

Varied accounts exist of the impact Wallis and Edward had on each other during their first meeting, but as they crossed paths time and again, Edward grew increasingly interested in this brash and brazen Marylander.

While Thelma was in New York, Wallis charmed Edward with her wit and intelligence. Before long, Wallis had replaced Thelma as the prince's mistress. Royal consorts were not a new thing, and most people wouldn't have blinked at their relationship. Not even Wallis's husband interfered, and the British press kept the story quiet.

But then, the prince's father died in 1936, and the young man was suddenly king. Edward felt that he couldn't rule without Wallis by his side—as his wife.

Others in the British government wouldn't consider the king marrying a divorced, common American woman who was still married to another man. Although divorce was legal in England, acquiring one was incredibly difficult, as it was allowed only when a husband cheated on his wife. Oddly, if the woman also cheated, the courts wouldn't grant the divorce.

King Edward and Wallis held fast that they only had a special friendship without having consummated their relationship. Not that they had done a particularly strong job of hiding their true feelings. He showered her with jewels and presents and took her and their friends on a cruise to the Dalmatian Islands. And while the British press continued to guard their secrecy, the international media, especially the newspapers in America, blared about it regularly.

Nonetheless, the king wouldn't be swayed. Even when Wallis recommended that they not marry, that it wouldn't be accepted, he refused to accept such a response. The couple suggested a morganatic marriage, in which Wallis would not be named queen but would receive a lower rank. The idea was summarily rejected by not only the British government but also those of other countries in the empire, from Australia to Canada.

Although her divorce was still proceeding and could yet be jeopardized, on December 11, 1936, King Edward abdicated the throne. He broadcast over the radio that "I have found it impossible to carry the heavy burden of responsibility and to discharge my duties as king as I would wish to do

Wallis Simpson (second from the left), the Duke of Wales (far left) and friends. *Library of Congress.*

without the help and support of the woman I love." His brother became King George VI.

While Edward was now free from his royal obligations, Wallis was still awaiting the court's ruling on her divorce. As such, the couple lived apart for several months, uncertain if they would ever be together.

However, the divorce was approved, and in June 1937, the couple was at last married. No one from the royal family attended. For years following the wedding, Edward, now the Duke of Windsor, fought with his relatives to have Wallis instated as the Duchess of Windsor and referred to as "Her Royal Highness." The family balked at the repeated requests, offering instead to refer to Wallis as "Her Grace." In private, however, they generally just called her "That Woman."

Wallis and her husband would spend almost the rest of their lives in absentia. England and its various affiliated countries refused to court the couple, but they found themselves welcomed in other lands, including most notably Germany. In one of their more controversial decisions, the couple met with Adolf Hitler, leader of the Nazi Party. Wallis's personal feelings on Nazism and Hitler are debatable,

but a photo of her hand being kissed by the Führer was widely circulated among the press and did little to enhance her reputation with England.

After World War II started, however, Wallis worked for various relief organizations, including the Red Cross in France and then with a USO canteen in the Bahamas. Her husband was named governor and commander in chief of the island. Although she served as the first lady, she apparently disliked the place, calling it "our St. Helena"—a reference to the island where Napoleon was exiled until his death.

After the war, the couple settled in France. Edward passed away in 1972, while Wallis survived until 1986. Unlike her outlandish life, she had a simple funeral. Indeed, according to her obituary with the BBC, "There was no funeral address, in accordance with the Duchess's wishes, and at no point in the service was there any mention of her name, or reference to her life. There were few flowers: most conspicuous was a single wreath of white, orange and yellow lilies from the Queen, which lay on her coffin." The majority of her multimillion-pound estate went to support the Pasteur Institute, a French medical research organization, as a thank-you to a country that, unlike England, had given her a warm and extended welcome.

Madalyn Murray O'Hair: Maryland's Most Hated Woman
1919–1995, Baltimore

In 1960, Madalyn Murray took her son Bill to Baltimore City's Woodbourne Junior High School, planning to enroll him. They were a few days into the semester already, so Madalyn was surprised at how remarkably quiet the school was. Through an open classroom door, she noticed a group of students—standing, heads down and saying the Lord's Prayer.

"Do they do this every day, or is this something special?" she asked Bill.

"Every day."

Madalyn continued to the admission counselor's office, but now she was seething. She told the young man there that she was enrolling her son, was an atheist and didn't want him praying at school. "It's un-American and unconstitutional."

The counselor suggested that she enroll her son in a private school if she didn't want him to participate. That, however, was missing the point. "It doesn't matter where I put him. You people have to be stopped."

"If you don't like it, why don't you sue us?" replied the counselor.

So Madalyn did.

Born Madalyn Mays in 1919, she grew up in a working-class family. In 1941, she eloped with John Henry Roths, two months before Japan attacked Pearl Harbor. John Henry enlisted with the marines, and Madalyn joined the Women's Army Corps. While serving abroad and away from John Henry, Madalyn became pregnant by William J. Murray Jr., an Eighth Army Air Corps B-24 pilot. However, William was unwilling to leave his wife for her, blaming his Catholic faith. With few options available, Madalyn returned to her parents' home with her brother in Ohio.

John Henry offered to adopt the coming baby, but Madalyn refused and divorced him instead. She named the boy William "Bill" Murray after his biological father and switched her last name to Murray as well. She filed and won a paternity suit against the baby's father, receiving fifteen dollars a month until Bill turned eighteen.

Although a single mother and working full time as a secretary, Madalyn went to college, receiving a degree in history and finishing second in her class. However, the rest of her family wasn't doing well, so everyone moved to Texas. While there, she went to law school, although she didn't pass the bar.

In 1952, the family relocated again—now to Baltimore. She ended up pregnant once more, having a boy named Jon Garth reportedly by a colleague, Michael Fiorillo.

In 1960, the *Baltimore Sun* ran an article about Madalyn's fight against Bible reading in schools. The concept was novel at the time. Dr. George Brain, the city's school superintendent, seemed perplexed at her concerns. "The school system must enforce the rule…requiring attendance at the opening exercises," he said, "The rule makes no provision for release from the class while the Bible is read. Those who do not want to participate must remain in class and be respectful." When Madalyn asked for her son to be allowed to wait in the library instead, the request was refused. According to the article, she removed Bill from school, tutored him at home and planned a hunger strike if taken to jail.

She had a hard time finding supporters. Madalyn had a volatile personality and was unabashed in her stark language choice and her belief that all religion was wrong. The Maryland ACLU refused to help her case. Eventually, she received legal representation from Leonard Kerpleman, a young attorney with his own set of peculiarities. Years later, he would be found dancing around a fountain at Hopkins Plaza while, fortunately, fully dressed.

Madalyn Murray-O'Hair. *Library of Congress.*

In 1963, Madalyn's suit joined that of another family—the Schempps—in going to the Supreme Court. The Schempp family were devoted Unitarian Universalists who valued free thinking. They were not seeking to rid the world of religion but saw Bible reading as a method of imposing one religion on others. The Schempps and Madalyn didn't get along well in person, but they understood that their cases would be stronger together than apart.

Also helping the families was that their suit was riding on the coattails of the *Engle* decision. Only one year earlier, the Supreme Court had agreed that prayer in schools was unconstitutional. This case took that a step further, and in the end, the court agreed. Mandatory Bible reading was removed from public schools.

She was reviled for the decision. In 1964, *Life* magazine ran an article entitled "The Most Hated Woman in America." She loved the title.

Madalyn's life would continue to be a series of frenetic, often fractious events. After pushing her teenaged son Bill to marry his pregnant girlfriend, the family ran afoul of the law, as the girl didn't have her parents' permission. When the police arrived, a mêlée broke out, and Madalyn suffered permanent injuries—which may have stemmed from her fighting with or defending herself from the authorities.

The family decamped to Hawaii until the state agreed to extradite them back to Maryland. Madalyn and Bill fled to Mexico. While there, she met and married Richard O'Hair. Eventually, a loophole in the law allowed them to return to the States as free people.

Madalyn settled in Texas and formed the American Atheists Association. In 1980, Bill converted to Evangelical Christianity and, not surprisingly, had a falling out with his mother.

In 1995, Madalyn, her younger son Jon Garth and her granddaughter Robin disappeared. Authorities assumed they had liquidized their assets and fled the country, escaping various inquiries into their finances.

In 2001, their bodies were recovered. They had been killed by one of her employees, David Waters. Unbeknownst to her when hiring him, David had a long rap sheet, including stints in jail for murder and fraud. After gaining Madalyn's trust, he swindled her. With his associate Gary Karr, the men kidnapped the family members and held them hostage for about a month before stealing more from them. Then, they killed the trio.

Although Madalyn was a polarizing figure, she never succumbed to societal expectations of what she should or shouldn't do. She firmly believed in her secular stance and would not be swayed to moderate herself, no matter the offer. She was not concerned about being liked—she apparently relished being hated—but she would not be ignored.

DIVINE: A DIFFERENT KIND OF WOMAN
1945–1988, Baltimore

Divine is perhaps the most outrageous woman to have originated in Maryland. The character, which starred in a number of films by local auteur John Waters, was proclaimed the "Queen of Filth." She existed to shock, entertain and repulse—generally all at the same time. And while Divine was fictional, she remains larger than life and is truly a "wild woman."

An oversized sculpture of Divine stands in the American Visionary Art Museum in downtown Baltimore, capturing the cinematic diva at her finest. Created by artist Andrew Logan, the sculpture stuffs Divine's voluptuous body into a skintight, shockingly red mermaid dress. Her blond bouffant appears to move, as if it were alive and growing. Her makeup is caked on, thick and heavy. The art is almost as over the top as the character herself.

And the man behind this vision of sky-high arched eyebrows, wiggle dress and stilettos is only slightly less so.

Divine came to life in the mid-1960s, when Harris Glenn Milstead—or Glenn—participated in his first film with John Waters, an avant-garde short entitled *Roman Candles*. Glenn had met John through mutual friend Carol Wernig. Carol and Glenn had been neighbors in Towson. In the documentary *Divine Trash*, John recalls how Glenn was renamed, saying, "Divine must have been named after the character in Jean Genet's novel, *Our Lady of the Flowers*, but for years I didn't think it was. It was a Catholic word that the nuns in school used to repeat over and over: 'This is divine, and this is divine,' on and on. I didn't remember the thing in *Our Lady of the Flowers*, although that must be impossible because I was reading that book when I christened Glenn, 'Divine.'"

Glenn was unlike other male performers portraying women. In the biography *My Son Divine*, John describes his vision, saying, "I wanted [Glenn] to be the Godzilla of drag queens…And the other drag queens were so square then. They wanted to be Miss America. Those were their values, and they hated Divine." Through the character of Divine, Glenn and John turned societal expectations of the female sex in on itself.

The trio was part of an experimental film entourage nicknamed the Dreamlanders, which also included such notables as Nancy "Mink" Stole and David Lochary. Under John's directorship, they used moviemaking to explore and push at expected standards of decency—a modern-day Dada movement and a precursor to the punk scene. Divine was often the central figure of these films, such as playing Jackie Kennedy in *Eat Your Makeup* and Diane Linkletter in *The Diane Linkletter Story*, to name a couple.

However, it wasn't just having an overweight man portraying a woman playing a character in tight clothes that pushed boundaries. The films pushed sexual limits as well, such as a simulated sex scene in *Multiple Maniacs* involving Divine, Mink Stole and rosary beads in a blasphemous manner. The group managed to avoid the state's censor boards by not showing its films in traditional movie houses but instead used atypical venues, like churches and university film fests.

They were not as lucky at being able to always avoid the police. Mink Stole remembered how when they were filming *Mondo Trasho*, "there was a scene where Divine picked up an imagined nude hitchhiker…Well, in order for that to appear on film, you actually had to have a nude hitchhiker." They filmed the scene in Baltimore's Charles Village. Actor Mark Isherwood waited in a robe until the right moment. They quickly got the scene shot, but

not before a Johns Hopkins University security guard noticed and called the police. John Waters recalled, "The cops came, and we ran. Divine escaped, dressed in a gold-lame toreador outfit, driving a 1959 Cadillac El Dorado with the top down and a nude man in the front seat."

Everyone was caught—except for Glenn. The ACLU took on the case, and the team was let go.

Glenn had been raised in a traditional, fairly conservative family in the northern suburbs of Baltimore. Born in 1945, he had a typical childhood, although early on, it became clear that he didn't fit the stereotypical masculine mold. After high school, he went to cosmetology school and soon joined a hair salon, becoming known for his elaborate creations. He also loved to host extravagant costume parties, where he often dressed as Elizabeth Taylor. However, while he enjoyed cross-dressing, he didn't necessarily identify as female. Still, he was gay and cross-dressing at a time when neither was socially acceptable.

While his work with the Dreamlanders was taking off, his relationship with his parents soured. Glenn ran up high bills for his parties, his car, gifts and other expenses that he either never paid or sent the invoices to his parents. Frustrated by his inability to restrain his spending, they eventually cut him off. In the biography *My Son Divine*, his mother, Frances, describes how she had taken the car away from him in early 1972. When he asked for it back, she said,

> *No, Glenn, you have used us long enough. You think more of your friends than your parents, so you can ask them to get you back to Provincetown* [where he was living at the time]. *What are you really up to there anyway?*
> He said, "I'm making a movie, and I'm Marie Antoinette."
> *Well, then I hope they do a good job when they cut off your head...Don't come back. Don't tell anyone you have a father or mother, and leave us alone.*

Glenn came back once, seeking the car, which they refused to give him. He left and didn't reconnect with them until 1981, except for sending postcards without return addresses. Glenn, however, had a different recollection of their estrangement, saying that they simply moved to Florida without telling him.

At the same time, Glenn's character's star was rising. The year 1972 was the same one that *Pink Flamingoes* was released. The premise of the film is a competition to determine who is the filthiest person alive. Divine, playing Babs Johnson, wins the title by eating dog feces, which Glenn actually did

during shooting. Although difficult to watch, *Pink Flamingoes* was a large success, leading to sold-out shows. John teamed up with New Line Cinema, which was only just starting out. The movie received significant press. *Variety* deemed the cast "the dregs of human perversity." Filmgoers couldn't get enough of how horrific and sensational it was. Many went time and time again, often to midnight screenings, à la *Rocky Horror Picture Show*.

After that, Divine portrayed in *Female Trouble* the fiendish Dawn Davenport, who goes on a rampage after she doesn't get the cha-cha heels she wanted for Christmas. Adding to the metaphysical layers of characters portraying characters, Glenn also played Earl Peterson, a villainous man who rapes Dawn. Following *Female Trouble*, Glenn sought work with other directors, starring in the off-Broadway plays and touring productions of *Women Behind Bars* and *Neon Woman*. He also kicked off a successful nightclub act as Divine.

In 1981, he returned to John Waters's films in *Polyester*—the first of John's works to receive an MPAA rating lower than X! It was a move toward the mainstream, although not as much as their biggest success together, *Hairspray*, which came out in 1988. *Hairspray* was a family-friendly film that showcased Baltimore in the 1960s. Divine played Edna Turnblad, the mother of Tracy Turnblad, the first starring role for Ricki Lake. Tracy, an overweight but optimistic teenager, sought to break down racial barriers on a local TV dance show. Both portrayals were breakout performances, and the movie received substantial positive critical reviews.

Unfortunately, Glenn never got to experience the afterglow of such acclaim. Not long after the film's release, he died in his sleep due to heart issues. His friend Anne Cersosimo recalls in *My Son Divine*, "The success and serious recognition for his work that he had craved for so long was seemingly within reach. He was making the dizzying round of talk shows and press interviews…He was going out to California to audition for *Married with Children* in a recurring role. I had booked a plane for a trip to Ibiza, where we were going to spend a month in May."

"Divine was a dear friend and my star," said John Waters at the funeral. "He was my Elizabeth Taylor…I never thought of Divine as a female impersonator. I thought of him as a great character actor that started his career playing a homicidal maniac and ended it playing a loving mother."

Hairspray went on to be as big—if not bigger—a success as anticipated. Although it enjoyed only moderate success in its initial release, the film became a cult classic and was popular on VHS. *Empire* included the film as one of its top five hundred movies ever made. In recent years, it was adapted

as a Broadway musical in 2002, winning eight Tony awards, including Best Musical. A second film version was released in 2007.

It all begs the question—if Glenn had survived, what might Divine have achieved next? And isn't that a question that rings true for all of Maryland's wild women?

SELECTED BIBLIOGRAPHY

PRIMARY SOURCES, ARCHIVES

Edward H. Nabb Research Center for Delmarva History and Culture
Enoch Pratt Free Library vertical files
Library of Congress files
Maryland Historical Society
Maryland State Archives
Western Maryland's Historical Library

NEWSPAPERS AND MAGAZINES

Baltimore Afro-American
Baltimore Sun
Leslie's Illustrated Weekly
Maryland Gazette
Maryland Journal & Baltimore Advertiser
New York Times
People Magazine
Washingtonian Magazine

SELECTED BIBLIOGRAPHY

SECONDARY SOURCES

Arnett, Earl, Robert J. Brugger and Edward C. Papenfuse. *Maryland: A New Guide to the Old Line State*. Baltimore, MD: Johns Hopkins University Press, 1999.

Beckles, Frances. *20 Black Women: A Profile of Contemporary Black Maryland Women*. Baltimore, MD: Gateway Press, 1978.

Boyd, Melba Joyce. *Discarded Legacy: Politics and Poetics in the Life of Frances E.W. Harper, 1825–1911*. Detroit, MI: Wayne State University Press, 1994.

Bradford, Sarah. *Harriet Tubman: The Moses of Her People*. New York: G.R. Lockwood & Sons, 1886.

Brugger, Robert J. *Maryland, A Middle Temperament: 1634–1980*. Baltimore, MD: Johns Hopkins University Press, 1988.

Cherry Spruill, Julia. *Women's Life and Work in the Southern Colonies*. New York: W.W. Norton & Co., 1972.

Cofield, Rod. "Women in Colonial-Era Public Houses." Speech. Historic London Town and Gardens, Edgewater, MD, n.d.

Cooke, William H. *Witch Trials, Legends, and Lore of Maryland: Dark, Strange, and True Tales*. N.p.: self-published, 2012.

Dracos, Ted. *Ungodly: The Passions, Torments, and Murder of Atheist Madalyn Murray O'Hair*. New York: Berkley, 2004.

Eggleston, Larry. *Women in the Civil War: Extraordinary Stories of Soldiers, Spies, Nurses, Doctors, Crusaders, and Others*. Jefferson, NC: McFarland & Company, 2003.

Eshelman, Ralph, and Scott Sheads. *Chesapeake Legends and Lore from the War of 1812*. Charleston, SC: The History Press, 2013.

Fitzgerald, Joseph. "Days of Wine and Roses: The Life of Gloria Richardson." Dissertation. Temple University, 2005.

Floyd, Claudia. *Maryland Women in the Civil War: Unionists, Rebels, Slaves and Spies*. Charleston, SC: The History Press, 2013.

Griggs, Catherine Mary. "Beyond Boundaries: The Adventurous Life of Marguerite Harrison." Dissertation. George Washington University, 1996.

Harrison, Marguerite. *Marooned in Moscow: An American Journalist-Spy Caught in Russia*. N.p.: self-published, n.d.

Helmes, Winifred. *Notable Maryland Women*. Cambridge, MD: Tidewater Publishers, 1977.

Jay, Bernard. *Not Simply Divine: Beneath the Makeup, Above the Heels, and Behind the Scenes with a Cult Superstar*. New York: Fireside, 1994.

Kenny, Katherine. *Juanita Jackson Mitchell: Freedom Fighter.* Baltimore, MD: PublishAmerica, LLLP, 2005.

Kenny, Katherine, and Eleanor Randrup. *Courageous Women of Maryland.* Atglen, PA: Schiffer Publishing, 2010.

Kisseloff, Jeff. *Generation on Fire: Voices of Protest from the 1960s, an Oral History.* Lexington: University Press of Kentucky, 2006.

Levy, Peter. "Civil War on Race Street: The Black Freedom Struggle and White Resistance in Cambridge, Maryland, 1960–1964." *Maryland Historical Magazine* 89 (1994).

———. *Civil War on Race Street: The Civil Rights Movement in Cambridge, Maryland.* Gainesville: University Press of Florida, 2003.

Logan, Rebecca. "Witches and Poisoners in the Colonial Chesapeake." Dissertation. Union Institute, Cincinnati, OH, 2001.

Luckett, Margie H. *Maryland Women: Baltimore, Maryland, 1931–1942.* N.p.: King Bros. Inc. Press, 1942.

Lussier, Betty. *Intrepid Woman: Betty Lussier's Secret War, 1942–1945.* Annapolis, MD: Naval Institute Press, 2010.

Marks, Carole C. *Moses and the Monster and Miss Anne.* Urbana: University of Illinois Press, 2009.

McIntosh, Elizabeth. *Sisterhood of Spies: The Women of the OSS.* Annapolis, MD: Naval Institute Press, 1998.

Meacham Thruston, Lucy. *Mistress Brent: A Story of Lord Baltimore's Colony in 1638.* Boston, MA: Little, Brown and Co., 1901.

Milstead, Frances. *My Son Divine.* Los Angeles: Alyson Publications, 2001.

Mitchell, Charles W. *Maryland Voices of the Civil War.* Baltimore, MD: Johns Hopkins University Press, 2007.

Pacheco, Josephine. *The* Pearl: *A Failed Slave Escape on the Potomac.* Chapel Hill: University of North Carolina Press, 2005.

Parke, Francis N. "Witchcraft in Maryland." *Maryland Historical Magazine* 31, no. 4. (1936).

Pearson, Judith L. *The Wolves at the Door: The True Story of America's Greatest Female Spy.* Guilford, CT: Globe Pequot Press, 2005.

Ricks, Mary K. *Escape on the* Pearl: *The Heroic Bid for Freedom on the Underground Railroad.* New York: Harper Perennial, 2007.

Ronne, Edith. *Antarctica's First Lady: Memoirs of the First American Woman to Set Foot on the Antarctic Continent and Winter-Over.* Sioux Falls, SD: Pine Hill Press, 2004.

Ross, Betsy M. *Playing Ball with the Boys: The Rise of Women in the World of Men's Sports.* Cincinnati, OH: Clerisy Press, 2011.

Ryon, Roderick R. "'Human Creatures' Lives': Baltimore Women and Work in Factories, 1880–1917." *Maryland Historical Magazine* 83, no. 4 (1988): 346–64. Baltimore, MD.

Sebba, Anne. *That Woman: The Life of Wallis Simpson, Duchess of Windsor*. New York: St. Martin's Press, 2012.

Semmes, Raphael. *Crime and Punishment in Early Maryland*. Baltimore, MD: Johns Hopkins University Press, 1938.

Shugg, Wallace. "The Socialite Spy from Baltimore: Marguerite E. Harrison, 1918–1922." *Maryland Historical Magazine* 103 (Spring 2008): 92–107.

Stegman, Carolyn B. *Women of Achievement in Maryland History*. Forest Hills, MD: Anaconda Press, 2002.

Tracey, Grace L., and John P. Dern. *Pioneers of Old Monocacy: The Early Settlement of Frederick County, Maryland, 1721–1743*. Baltimore, MD: Clearfield Co., 1987.

Vickers, Hugo. "Behind Closed Doors: The Private Sorrow of Wallis Warfield Simpson." *MdHS News* (Fall 2011): 28–31.

Wexler, Natalie. "'What Manner of Woman Our Female Editor May Be': Eliza Crawford Anderson and the Baltimore *Observer*, 1806–1807." *Maryland Historical Magazine* (Summer 2010): 100–31.

Winkler, H. Donald. *Stealing Secrets: How a Few Daring Women Deceived Generals, Impacted Battles, and Altered the Course of the Civil War*. Naperville, IL: Sourcebooks, 2010.

Wright, Lawrence. *Saints and Sinners*. New York: Knopf Doubleday Publishing Group, 1993.

Wroth, Lawrence C. *A History of Printing in Colonial Maryland, 1686–1776*. Baltimore, MD: Typothetae of Baltimore, 1922.

INDEX

INDEX

INDEX

T

Talbot County 37
Tennessee 51, 82
Tennessee River 50
Turkey 61

U

Union 11, 44, 46, 48, 50, 51, 72
University of Maryland 84

V

Victorian 65, 111, 113
Virginia 20, 22, 27, 45, 48, 50, 97, 112

W

war 20, 39, 41, 46, 50, 52, 53, 54, 57,
 58, 61, 62, 63, 73, 98, 100, 101
War of 1812 40, 44
Waters, John 132, 133, 134, 135
Westminster 100
Wharton, Ellen 15, 120, 122
Whig 49
witches 33, 36, 37
World War I 52, 53, 54, 57, 81, 101
World War II 57, 61, 129

X

X-2 60, 61

Y

yellow fever 68

ABOUT THE AUTHOR

Lauren R. Silberman is the author of *Wicked Baltimore: Charm City Sin and Scandal* (The History Press) and *The Jewish Community of Baltimore* (Arcadia Publishing). Ms. Silberman is the deputy director of Historic London Town and Gardens in Edgewater, Maryland, and a board member of the Small Museum Association. She is also the treasurer for the Friends of the Greenbelt Museum and a committee member for the Anacostia Trails Heritage Area. She lives in Greenbelt, Maryland, with her husband.